MW00634824

IMAGES
of America

SEA ISLE CITY

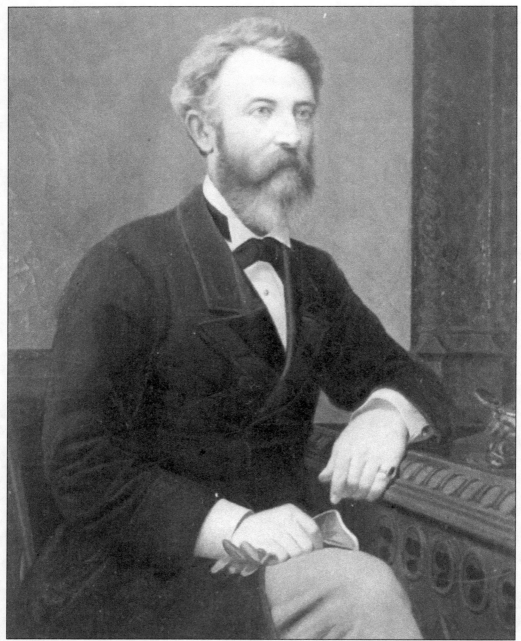

Charles K. Landis purchased Ludlam's Island in 1880. He developed much of this island, which later became Sea Isle City. He is also credited with the development of both Hammonton and Vineland, New Jersey. Born in 1833, Landis began his study of law at age 15. Over the years, he lived in Philadelphia and Lancaster, Pennsylvania, and in Atlanta and Macon, Georgia. He died in 1900.

IMAGES
of America

SEA ISLE CITY

Michael F. Stafford

ARCADIA
PUBLISHING

Copyright © 2001 by Michael F. Stafford
ISBN 978-1-5316-0331-1

Published by Arcadia Publishing
Charleston, South Carolina

Library of Congress Catalog Card Number: 2001088680

For all general information contact Arcadia Publishing at:
Telephone 843-853-2070
Fax 843-853-0044
E-mail sales@arcadiapublishing.com
For customer service and orders:
Toll-Free 1-888-313-2665

Visit us on the Internet at www.arcadiapublishing.com

Today and Yesterday
Sea Isle City Streets

Today	Yesterday	Today	Yesterday	Today	Yesterday	Today	Yesterday
1st	Polk	25th	Prospect	49th	Dolphin	73rd	Fourth
2nd	Tyler	26th	Devon	50th	Shell	74th	Fifth
3rd	Harrison	27th	Lansdowne	51st	Erin	75th	Sixth
4th	Van Buren	28th	Belmont	52nd	Albion	76th	Seventh
5th	Jackson	29th	Rosewood	53rd	Vineland	77th	Eighth
6th	Monroe	30th	Westphalia	54th	Hammonton	78th	Ninth
7th	Madison	31st	Whelen	55th	Ludlam	79th	Tenth
8th	Jefferson	32nd	Elm	56th	Prince	80th	Eleventh
9th	Adams	33rd	Farrand	57th	Union	81st	Twelfth
10th	Washington	34th	Maxham	58th	Spring	82nd	Thirteenth
11th	Wisconsin	35th	Mathilda	59th	Knowles	83rd	Fourteenth
12th	Virginia	36th	House	60th	Spenser	84th	Wharf
13th	Missouri	37th	Hartson	61st	Cowper	85th	Cedar
14th	Florida	38th	Swain	62nd	Williamson	86th	Rose
15th	Ohio	39th	Garrison	63rd	Byron	87th	Storm
16th	Maryland	40th	Fritz	64th	Shelley	88th	Surf
17th	New York	41st	Ocean	65th	Otway	89th	Raleigh
18th	Douglass	42nd	Italia	66th	Bulwer	90th	Charleston
19th	New Jersey	43rd	Paris	67th	Bryant	91st	Atlantic
20th	McClellan	44th	Minerva	68th	Burns	92nd	Miami
21st	Hancock	45th	Ariadne	69th	Cowley	93rd	Daytona
22nd	Pennsylvania	46th	Neptune	70th	First	94th	Columbia
23rd	Philadelphia	47th	Coral	71st	Second	95th	Inlet
24th	Girard	48th	Pearl	72nd	Third		

In more recent times, the east-west streets of Sea Isle City were numbered starting with First Street and ending with 93rd Street in Townsend's Inlet at the south end of the island. In earlier days these same streets were named after historical figures, places, and things.

CONTENTS

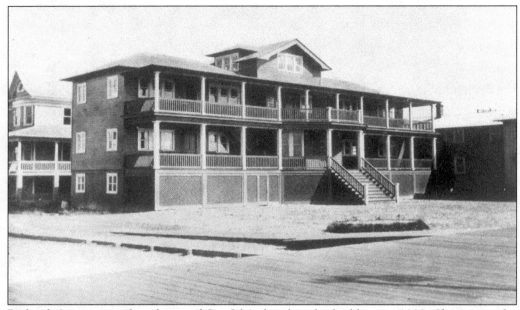

Richard Atwater purchased one of Sea Isle's first lots for building in 1880. Shown are the "barracks" and, to the north, the family home. Atwater, one of the founders of the yacht club, became mayor of Sea Isle in 1913.

Acknowledgments

My sincere thanks to those people who either directly or indirectly assisted me in the writing of this book. The Sea Isle City Historical Museum provided some of the many photographs contained in the book, as well as pertinent data related to the history of Sea Isle City.

I am appreciative of the effort put forth by Harriett Reardon Bailey, curator of the Sea Isle City Historical Museum, in researching and compiling the data related to the railroads. Thanks also to Jim and Rosalie Trainor, who photographed many of the old homes still present on the island. They captured an important part of the town's history, which I have included in this book for all to share.

Other individuals on a continuing basis provided invaluable information and insights related to Sea Isle City and its people. Sis Bonitt, Sea Isle City Historical Museum librarian, and all the library volunteers helped in this way. Thanks to Pat and Florence La Rosa, who throughout my lifetime have shared their extensive knowledge of the resort's history with me, particularly in regard to the townspeople and family interrelationships. They also enlightened me on the development of the commercial fishing industry. Pat La Rosa, who passed away recently, would be proud to know that his vast knowledge of the fishing industry will now be shared by future generations. Thanks also to Don Cramer and Kitty Clancy Thompson for sharing photographs and information.

The individuals who make up the Sea Isle City community are a special brand of people. Thank you for providing all of us with a town that I can be proud to write about.

Finally, I want to express my indebtedness to my wife, Marie, who not only has assisted me every step of the way in writing this book but also, and far more importantly, has been a motivating force. Without her I would never have undertaken this project.

INTRODUCTION

In the early 1870s, Charles K. Landis returned from a visit to Italy. He was so impressed with many of the Mediterranean towns he had visited that he was inspired to create an Italian-style resort town in this country. Thus, his dream was born. It has been said, "Each age is a dream that is dying or a dream that is coming to life." This is the fascinating story of how Sea Isle City, located along the New Jersey coast in Cape May County, was born and has evolved through the years.

Landis, a man with a dream, was also a man of action. Almost overnight, Sea Isle City became accessible by railroad and by turnpike. Hotels and cottages appeared throughout this island by the sea. Work started in 1880, and Sea Isle City became a borough in 1882. The Landis vision and planning were embraced by a dedicated and hardworking group of citizens, headed by the town's first mayor, Martin Wells. As the 20th century began, the seashore resort was on the map, boasting of some of the finest tourists facilities along the New Jersey coast. Fine restaurants and an abundance of additional facilities were rapidly put in place to accommodate the growing population.

While all of this was evolving, Sea Isle City's industry also came into existence. The *Cape May County Times*, a local newspaper, is one example. William A. Haffert Sr. acquired the newspaper in 1914 and soon developed the Atlantic Printing and Publishing Company, later to be renamed the Garden State Publishing Company. Haffert also served as mayor from 1945 to 1956. Commercial fishing also contributed early to the town's economy thanks to, among others, the "Hatmen," a group of young men who had worked at the Stetson Hat Company in Philadelphia. They came to Sea Isle City to engage in the fishing industry, having found it to be healthier than working around the steam pots at the hat factory. Others came from New York City.

Quality restaurants also drew tourists to Sea Isle City. Cronecker's Hotel and Restaurant, originally called the Bellevue, and Busch's Hotel and Restaurant served the finest food. Busch's is still in business today in Townsend's Inlet at the south end of the island.

The first school was housed in the old dining room of the Aldine Hotel on 38th Street. The original post office was located on the southwest corner of 44th Street and Landis Avenue. George Whitney was the postmaster.

In addition to the *Cape May County Times*, a German newspaper was circulated to serve the many German settlers. Fini Stampfl Jones was kind enough to translate a copy of this newspaper into English. A copy of the paper with her translation from old German is on display in the Sea Isle City History Museum.

Transportation was interesting in the town's early days. In addition to the railroad trains and automobiles, one would see horses and carriages. As time passed, automobiles began to appear

in greater numbers. Horse-and-carriage travel limited a typical day trip to 12 miles or so. In an automobile, people could travel 70 miles or more away from home, as they also could by train. Until about 1920 people could go from one end of the island to the other by trolley car. The Sea Isle City History Museum has the original trolley car bell. All of these improvements in transportation promoted growth on the island.

Sea Isle City's broad, flat, sandy beaches represent the single most important feature that drew people to the island. Fireworks, motorcycle racing, clambakes and, of course, sunbathing and swimming were all available to the tourist.

The years of Sea Isle City's growth and development were not always easy ones. The resort town was the victim of many battering storms. Its people also had to survive the Great Depression, as well as World War I and World War II. Charles K. Landis, the man with a dream and the ability to take action, indeed is to be praised. Above all, however, it was the dedicated people who are to be recognized for the town's early growth. Their persistence to move forward, no matter what the challenge, molded Sea Isle City into, for many, a model resort town and, for others, a year-round community. These early pioneers will long be remembered.

A picture is worth a thousand words. With that thought in mind, the following pages are intended to provide you with fascinating images that will allow you to pause, step back in time, and know life as it once was lived in Sea Isle City.

One

EARLY TIMES

The Lenni Lenape Indians were the original visitors to the island that became Sea Isle City. They came from the mainland to gather shells for wampum, the currency of the day. Just as others do today, they must have enjoyed the warmth of the sun, the beaches, and the Atlantic Ocean.

In 1692, Joseph Ludlam purchased the island, which at the time was used for cattle grazing. Cattle swam across the bay from the mainland, and sheep were brought over in boats. Cattle were still on the island as late as the 1870s. The inlets at each end of the island were named after early pioneers on the mainland. The north end of the island inlet was named after the Corson family, and the south end of the island inlet was named after the Townsend family. The beach and bay area were named after Ludlam.

Throughout the years many shipwrecks brought "visitors" from the sea to the island. Whalers from New England also visited the area. The federal government built lifesaving stations up and down the East Coast to minimize the number of shipwrecks, which were constantly occurring. Life Saving Stations Nos. 33 and 34 were on the island. Ludlam's Beach Lighthouse was erected in 1885. It stood 36 feet high and could be seen about 12 miles out at sea in clear weather. This lighthouse was replaced c. 1923 with a modern steel tower that held a light.

After Charles K. Landis purchased the island in 1880, things began to happen rapidly. Landis had earned the reputation as a reputable developer as a result of his earlier founding of Vineland. At that time, Vineland had the largest area of any city in New Jersey.

On May 16, 1882, Sea Isle City elected its first officials, among them Martin Wells as the first mayor. It is interesting to note that descendants of most of the original officials still live in Sea Isle City and offshore today.

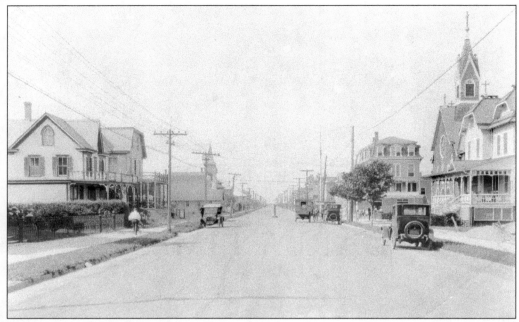

The 1920s and 1930s automobiles add a nice touch to this view, which also shows a horse and wagon. Perhaps the horse and wagon delivered mail, since the four-story building across from St. Joseph's Church was once the post office. That building, located at the intersection of 44th Street and Landis Avenue, later belonged to the Vassallo family.

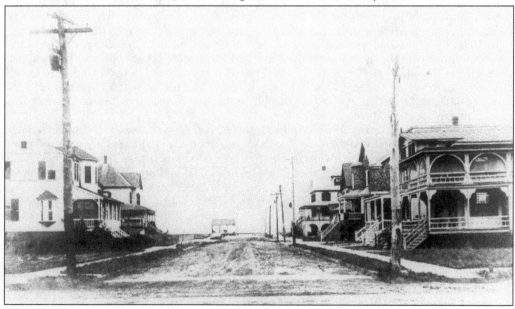

This view is looking east toward the ocean along 46th Street from Landis Avenue. Shown on the right is the Centennial House, so called because it was one of several that were displayed during the Philadelphia Centennial and then floated to Sea Isle on barges. Labeled "Italianette," the house contained two units side by side. Originally owned by two sisters, it was later purchased by the Glatz family, who sold the property in 1992. It was recently demolished.

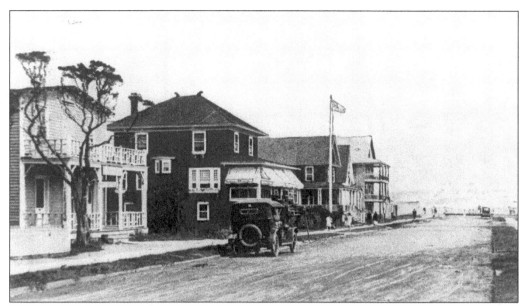

This view looks east to the beach along Paris Street, which later became 43rd Street. The second house from the beach was the home of Martin Wells, Sea Isle's first mayor. Later, it belonged to Jack Gordon and his wife, Theresa, whose parents ran Travascio's Restaurant across the street. The house in the foreground displays a post office sign.

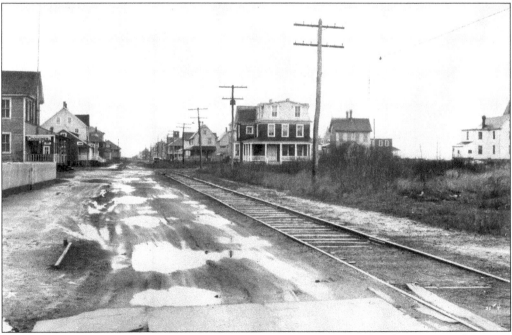

This view looking north on Pleasure Avenue shows the former Wilsey home on 39th Street, with a grocery sign displayed on the porch. Next in line is a cottage that belonged to the Dramis family. The train track ran the entire length of the island until the mid-1930s, when automobiles became more plentiful.

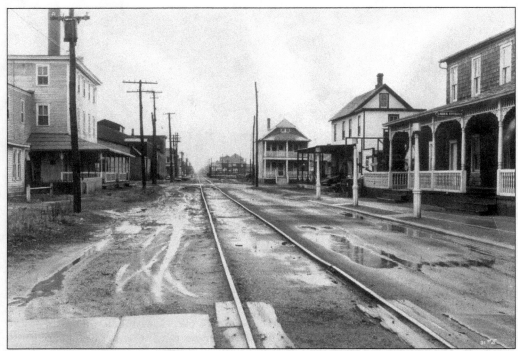

In this view, looking south from 39th Street along Pleasure Avenue, the "ladies' entrance" to Busch's Hotel can be seen on the right. The next building is Struther's and across from that, the Pennsylvania Hotel. In the background are the tennis courts that the city provided.

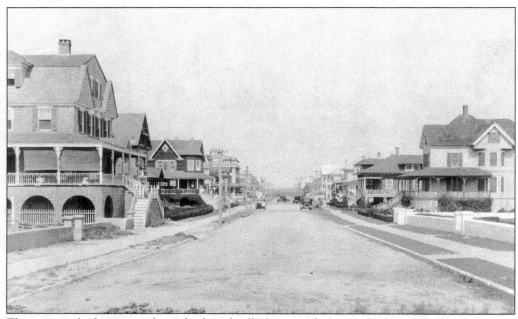

This view is looking west from the boardwalk down 46th Street. It shows a railroad crossing sign on Pleasure Avenue. People are clad in warm-weather attire. Note the seawalls around the two beachfront houses in the foreground.

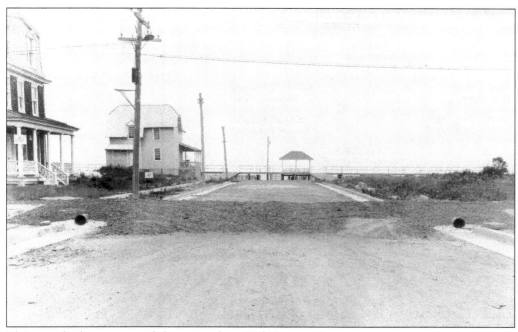

This view looks east toward the ocean from 39th Street. Pleasure Avenue is in the foreground. Note the drain pipes and also the pavilion, which is along the boardwalk. Many pavilions were provided along the boardwalk so that people could sit and take in the wonderful view.

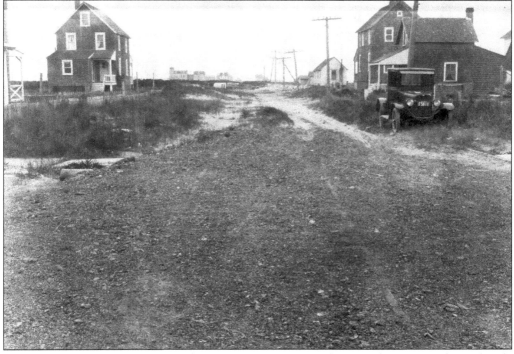

In this view, looking north along Pleasure Avenue from 32nd Street, the train tracks are barely visible. The Pitta Luga family amusement park Fun City was located here from 1963 to 2000.

THE FIRST OFFICIALS OF SEA ISLE CITY, NEW JERSEY
Elected May 16, 1882

MAYOR
Martin Wells

MEMBERS OF COUNCIL

James P. Way
Roger Dever

William L. Peterson
Hudson Ludlam

BOROUGH CLERK
Jacob L. Peterson

TAX ASSESSOR
Thomas E. Ludlam

COLLECTOR
James P. Way

CHOSEN FREEHOLDERS
William L. Peterson
Thomas E. Ludlam

SURVEYORS OF THE HIGHWAYS
Roger Dever
Hudson Ludlam

COMMISSIONERS OF APPEALS IN CASES OF TAXATION
Hudson Ludlam
Martin Wells
James P. Way

JUDGE OF ELECTIONS
Matthew Hand, Jr.

INSPECTORS OF ELECTION
Aley Hildreth
Henry Ludlam

POUND KEEPER
Charles Hackman

Many of the family names of this first governing body are still familiar, nearly a century and a quarter later. For example, descendants of the Dever family live in Sea Isle today.

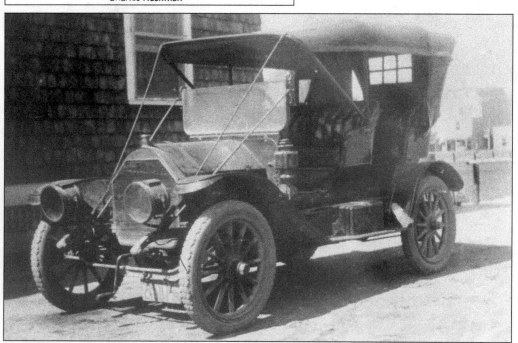

This 1910 automobile was said to be one of the first on the island. It belonged to Bernard J. Quinn, a Philadelphia businessman who served as mayor of Sea Isle from 1908 until 1910. Can you imagine a trip to Philadelphia in this vehicle?

Two

HOUSING AND HOTELS

An advertisement in the *Cape May County Times* of December 25, 1891, highlights the advantages of visiting Sea Isle City and depicts the mood and spirit of the times: "In going to Sea Isle, you will always find good hotels and boarding houses open at moderate charges, and sailing boats at the inlet and turnpike bridge. Excellent bath-houses, an elegant Casino and Excursion House—the finest on the coast—a sea wall or embankment several hundred feet long, with a boardwalk on the top of it. No place has improved more rapidly than Sea Isle City."

Persons interested in particulars about investment and visits to Sea Isle City were asked in the same advertisement to contact C.K. Landis, founder, 402 Locust Street, Philadelphia. Much emphasis was placed on promoting Sea Isle City as both a summer and winter resort. Most of the hotels and rooming houses were open year-round.

With the development of the automobile still in its infancy, much emphasis was placed on the availability, ease, and comfort of travel to the resort by train.

Hotels, many of which had restaurants, catered primarily to the tourist on short visits to the resort. Rooming houses and apartments were available for people who wished to spend longer periods of time on vacation. Although not as elegant as hotel accommodations, these rooming houses and apartments had a certain charm. They offering extended vacation time and the opportunity to mingle more readily with other families and to form lasting friendships.

Whether observing life in Sea Isle in the earliest days or in the century that followed, it has always been true that the people on the island, year-round or seasonal, are what make the town so warm and attractive to the newcomer.

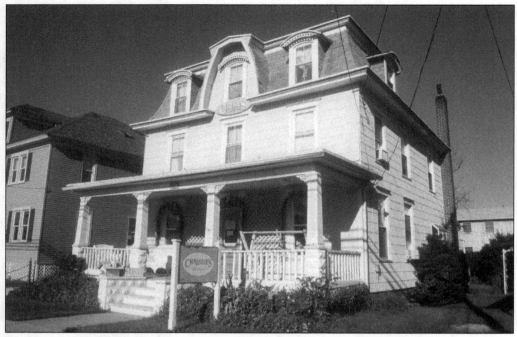

This large older home at 38th Street and Landis Avenue was once owned by the family of Mayor Thomas Ludlam and later by the Jefferson family. While restoring the house, Chrissie and Mark Ternosky found an old Ludlam Delivery Company ledger in the attic.

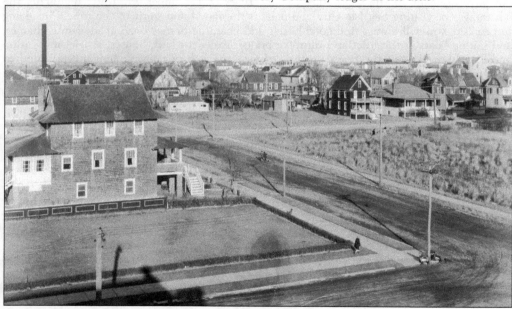

This view from 45th Street near Central Avenue shows the Bonitt home on the left. Barely visible on 44th Street is a 1920s automobile parked in front of former Mayor Vincent La Manna's home. The water tower is on the left. The open lawn in the foreground was part of Mayor William A. Haffert Sr.'s home. Notice the heavy outer garb worn by the few pedestrians in this winter scene.

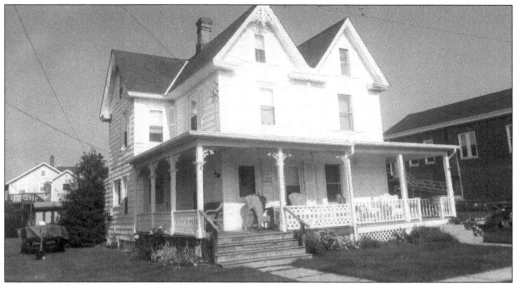

This lovely Victorian building, the right half of which is the summer home of the Kuttler family, is located on 45th Street behind Sea Isle City Hall, shown on the right. Many such homes could be found throughout the island. A few still remain today.

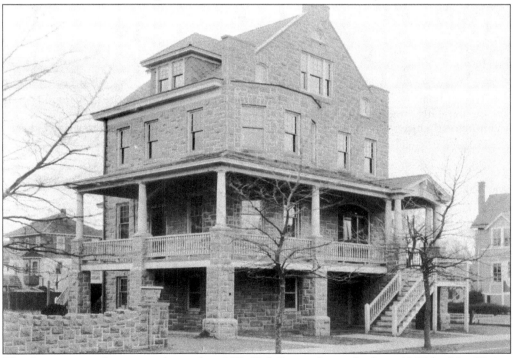

This large granite home was located at 118 43rd Street. It was built in 1915 by Mr. Cini, a successful spaghetti manufacturer. It was a 15-room Italian villa–style house with 3,600 square feet of space. Artisans who came from Italy hand carved the North Carolina granite used in construction of the building. The home was later owned by the Frosh family before it was purchased by St. Joseph's Parish and demolished to provide parking.

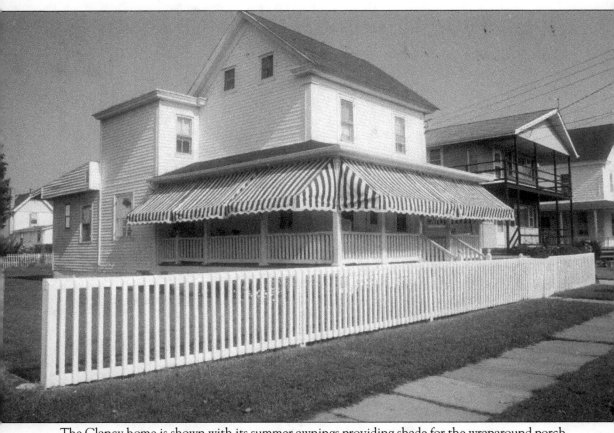

The Clancy home is shown with its summer awnings providing shade for the wraparound porch. Located on 45th Street, it is one of many older homes on this block, which is known as "the widows street" since so many women have survived their husband and lived to a ripe old age.

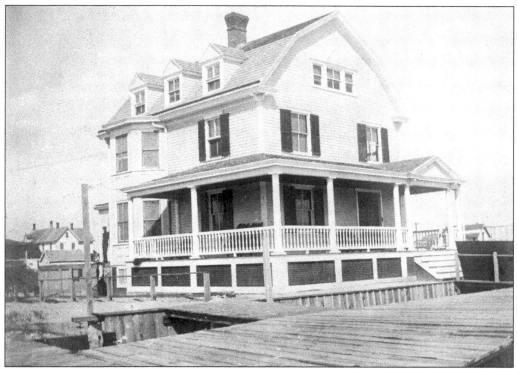

This c. 1890s view along 51st Street shows the Toohey home. The scene indicates that Sea Isle City had a boardwalk at that time. Rocking chairs, usually painted dark green, were typically found on the open porches. One could rock away and enjoy the sight of the ocean.

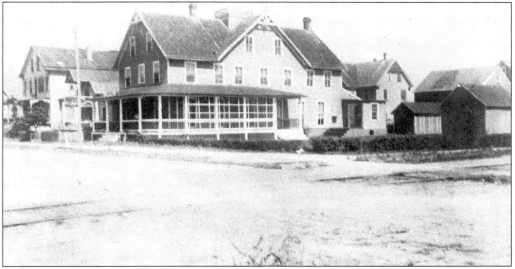

This was the summer home of Dr. and Mrs. T.C. Wheaton. The Wheaton family owned a glass company, which was a major industry in South Jersey. Wheaton glassware is still highly prized today. The house, located at 38th Street and Pleasure Avenue, later became the Aldine Boarding House. In 1944, the Dramis family bought it and resided there for many years. Note the lovely garden on the right.

19

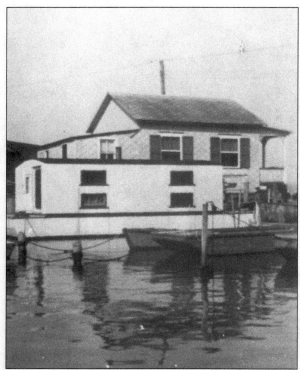

This houseboat, berthed at 59th Street and Sounds Avenue at the Sea Isle City Municipal Pier, was the home of Mr. Snow. Well known as an expert fisherman, Snow resided here from the 1920s into the late 1930s. He always had a pleasant smile and a bit of advice for anyone using the municipal pier.

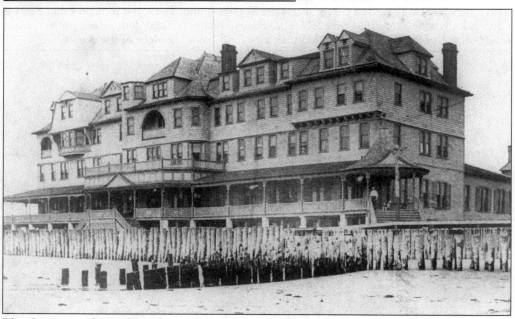

The Continental Hotel was located on the beach, extending from 25th to 26th Street. Built in 1889, the hotel was five stories high and had the only steam elevators along the coast to transport guests to the upper floors, where the view of the Atlantic Ocean was breathtaking. The boardwalk extended from center of town all the way to 25th Street in front of this grand hotel, which was torn down in 1905.

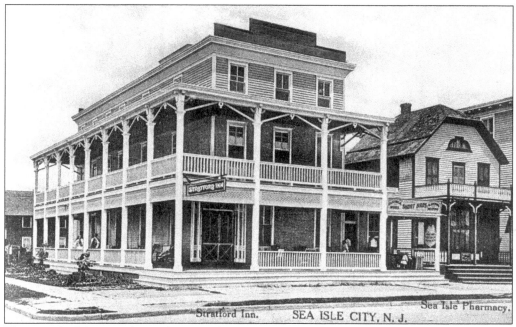

The Stratford Inn was located on Landis Avenue at 42nd Street. Centrally located, it was a temperance hotel that advertised monthly rental rates of $60 on a yearly basis. An advertisement in a local newspaper of the time mentions vegetables delivered to the door by farmers. Just to the right of the inn was the local pharmacy.

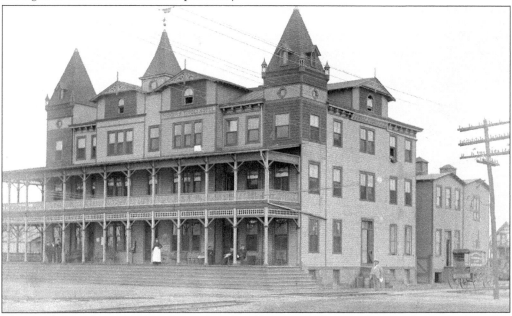

The Tivoli Hotel, c. 1900, was located at 41st Street and Pleasure Avenue. It was built with a cupola and wide multistoried porch decks. Vince's famous hoagie shop was located here many years later after the Tivoli Hotel was destroyed by fire. The Epicurean Restaurant is currently at this location. Note the horse and carriage and the train tracks in this early scene.

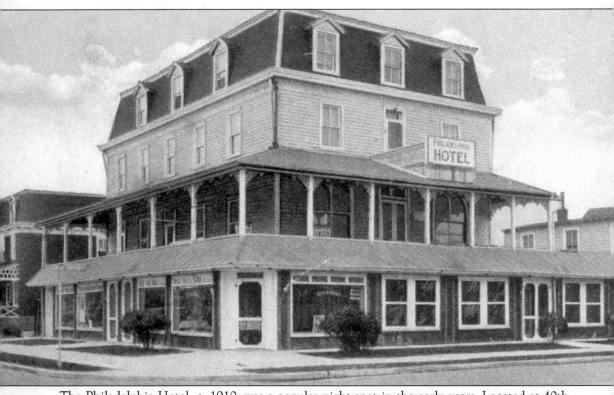

The Philadelphia Hotel, c. 1910, was a popular night spot in the early years. Located at 40th Street and Landis Avenue, it later became the Ocean Drive Hotel, which continues to thrive today. Many of the town's important events are held here. Joe Roberts is the present owner. Previous owners were the Luongos, Melonis, Dogliottis, and Ferronis.

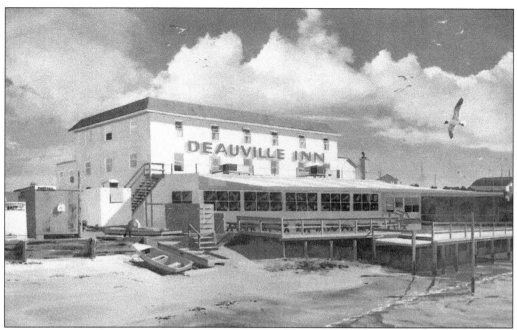

The Deauville Inn, located along the bay at the far end of the island in Strathmere, was originally called the Whelan Hotel and is believed to have been built in 1871. The artist's rendering shown here was done in more recent times. Although time moves on, the Deauville Inn continues to provide a welcome spot to relax, have a good time, and be entertained.

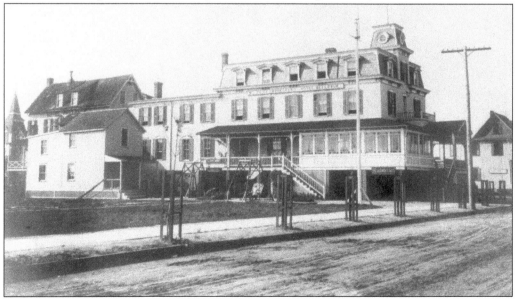

Fritz Cronecker's Bellevue Hotel, located at 40th Street and Landis Avenue, is shown c. 1900. The hotel was open year-round and did a thriving business. Visitors to the Sea Isle City Historical Museum can look through an old register of the hotel's guests, which is on display. Visible in the left background of this scene is the steeple of the old Methodist church. In 1905, the church was moved to 45th Street and Landis Avenue.

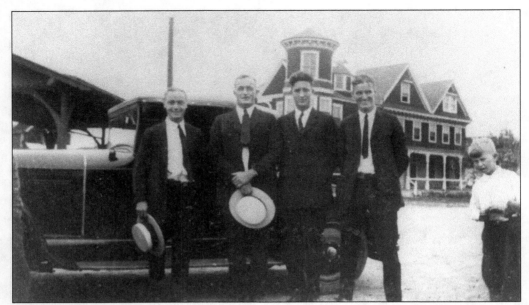

These somewhat formally attired men are standing outside the Depot Hotel, located near the railroad station. The automobile behind them is waiting to receive passengers from a train soon to arrive. Just like the youth of today, the young lads on the right show an interest in having their picture taken. The Depot Hotel was a hubbub of activity during the first third of the century.

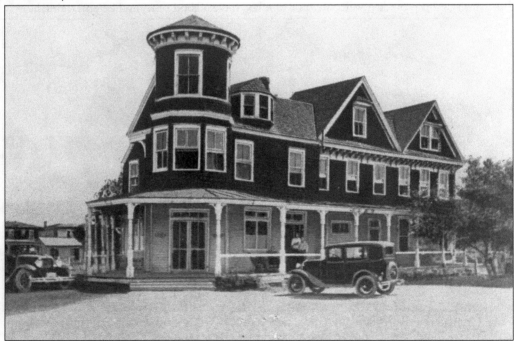

The Depot Hotel, which opened in 1883, was located near the present post office on JFK Boulevard. Originally called the Fritz Cronecker Depot Hotel, it was owned at various times over the years by the Brights, the Harlans, and the Killhours. It was torn down in 1938.

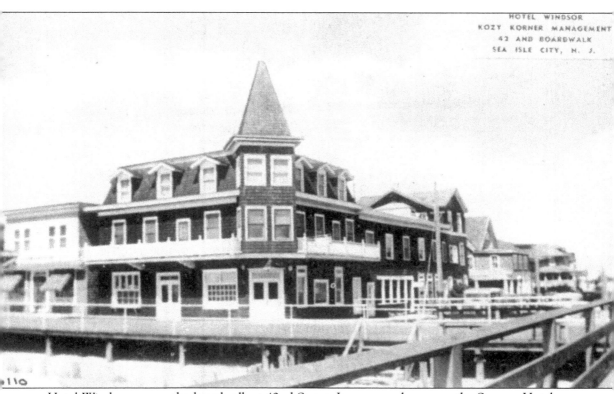

HOTEL WINDSOR
KOZY KORNER MANAGEMENT
42 AND BOARDWALK
SEA ISLE CITY, N. J.

Hotel Windsor was on the boardwalk at 42nd Street. It was once known as the Stevens Hotel. The Windsor had the Kozy Korner Restaurant, which was a popular spot. After church on Sunday, the restaurant would be overflowing with patrons—all of them wanting window booths.

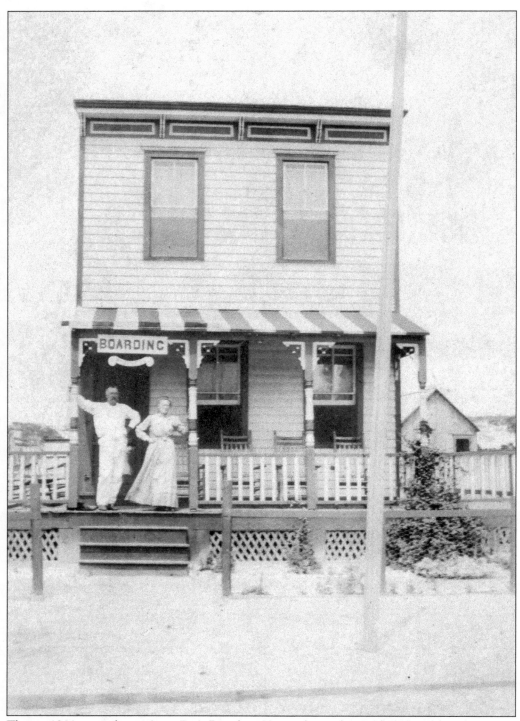

This c. 1900 view shows Aunt Em's Boarding House, located at 86th Street (then known as Rose Street) in Townsend's Inlet. It was the place where Arnold Cramer stayed from 1900 to 1908. During that time, he started his fishing business with the Allard sailing vessel.

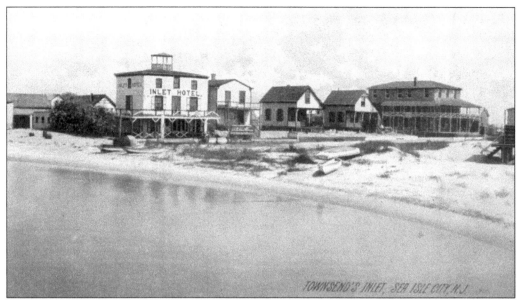

The Inlet Hotel was operated by George Pfeiffer in 1891. It was advertised as being ideal for boating, fishing, and gunning. In the 1940s, the hotel had a "teenage bar" that featured dancing nightly. Near beer—malt liquor that was practically alcohol free—was a popular drink with young people. Busch's Hotel is on the far right.

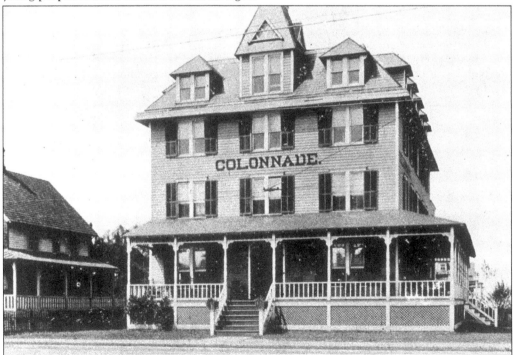

This *c.* 1910 view shows the Colonnade Hotel, which for many years was owned and operated by the Dorsam family. Located on the southwest corner of 46th Street and Landis Avenue, it has been restored by Dr. Caroline Crawford and is an elegant bed-and-breakfast establishment today.

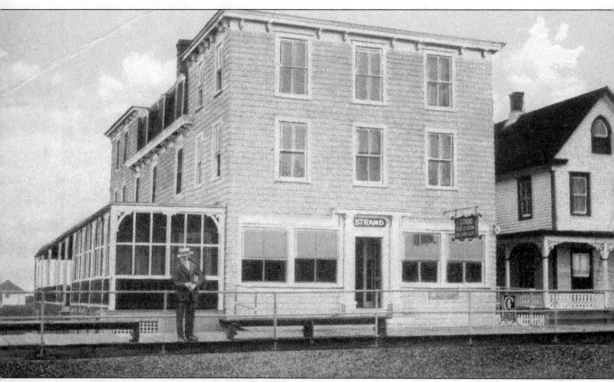

This *c.* 1920 view shows the Strand Apartments, located at 55th Street and the boardwalk. The building was originally known as the All Saint's Seashore House. It was purchased by John and Mary Cassidy in 1917, and major alterations were completed to enlarge the upper levels of the building. It then became a 40-room complex with apartments, a community kitchen, and a community dining room. Mary Cassidy continued to operate the business until 1947, when she sold it to Al and Florence Wagner. The Strand was demolished in the late 1950s.

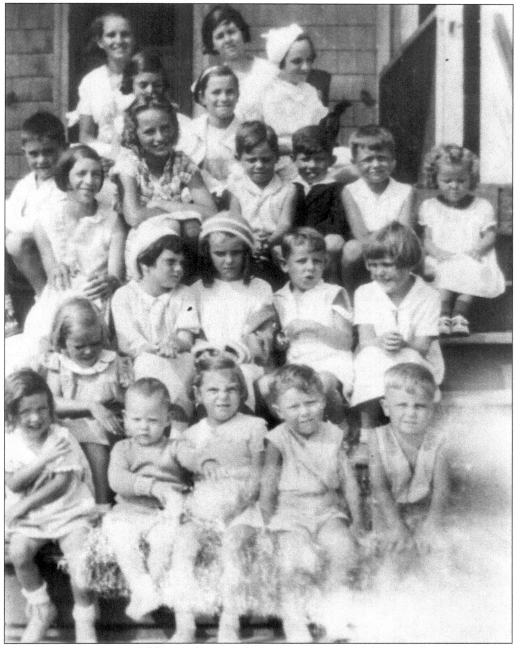

This 1930s scene shows children at the Strand Apartments. Some of them are the grandchildren of Strand owner Mary Cassidy, and others are the children of renters. This author is among the group.

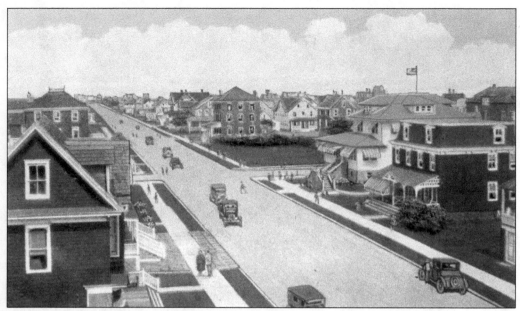

This view shows the intersection of Landis Avenue and 39th Street. The Central Hotel on the northwest corner has a widow's walk, where the fishermen's wives looked to see the boats return safely. The house on the northeast corner belongs to the Dogliotti family. Next door is the twin house, where the Thompson and Dempsey families lived. O'Donnell's Irish Pub is currently located there.

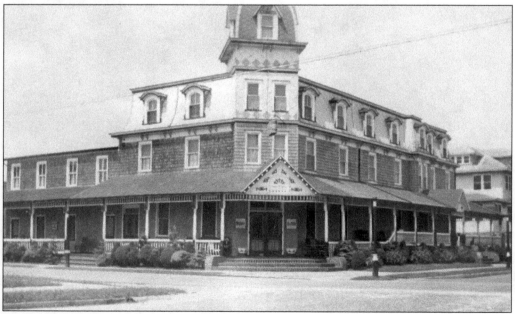

This c. 1910 view shows Busch's Hotel and Restaurant, a 52-room building on the southwest corner of 39th Street and Pleasure Avenue. It was constructed in 1882 by George Busch and his wife, Anna. In the 1940s, they sold the building to the Myhre family and moved the business to its present location at 87th Street and Landis Avenue.

Three

COMMERCIAL AND SPORT FISHING

Fishing, commercial and sport, done from the beach, the bay, or deep sea, has always been important in Sea Isle City.

Sport fishing has continuously held the distinct advantage of being carefree. If you caught 'em, great! If not, you could always lie about it. No matter what, most leisure-time fishermen enjoyed the pastime immensely. The Ocean Pier, later called Cini Pier, was purchased by the Braca family in 1940. The pier housed a movie theater, later renamed the Madeline in honor of Mrs. Braca. The pier was a favorite spot from which to cast a fishing line. Others preferred surf fishing right from the beach. For a change of pace or simply through preference, many fished the back-bay waters, either from the various fishing piers, the bridge, or from small boats. If you liked flies, the bay was the place to find them. Some say the green heads were as big as roaches.

Party boats have been popular in Sea Isle City for the past century. Party boat captains know where the fish are. From the earliest of times, it was common for day excursions by train to arrive with a trainload of anxious fishermen who were ready to climb aboard one of these party boats and head for the deep waters. Others have enjoyed the sightseeing cruises provided by these boats.

Unlike sport fishing, commercial fishing has always been a bread-and-butter issue. When these seafarers go out into the ocean, the pressure is on. They need a good catch if they and their families are to survive. Although some commercial fishing is still done today, the volume of this fading occupation lessens as the years go by. It is interesting to stroll along the docks and listen to these fishermen boast about the huge catches that used to be so common. "The fish just are not out there like they used to be" is a phrase one often hears. Without question, Sea Isle City's rapid and solid growth was largely due to these dedicated seafarers, who developed an industry that helped to keep this resort's economy strong for most of the past century.

Lou Bufalo continues the family tradition of trawler net fishing, which was started by his father, Camillo, in the 1920s. Lou's sisters Anne Marie and Gloria successfully own and operate the Lobster Loft restaurant in Sea Isle City.

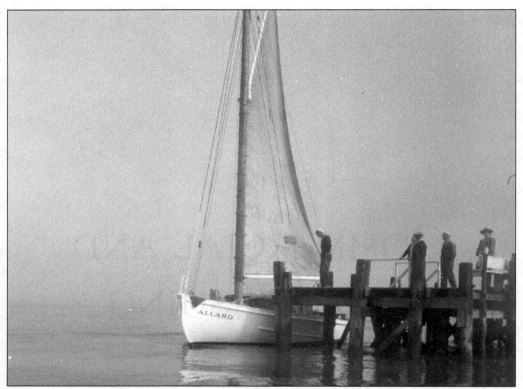

Capt. Arnold Cramer operated the cat yacht *Allard* from 1900 until he sold the boat in 1944. For the first eight summers, Cramer sailed both in and out of Townsend's Inlet by sail alone, without the aid of a motor. This had to have been a harrowing experience—one that required much skill.

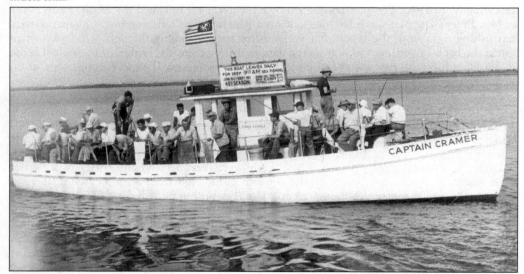

Pratt Cramer, the son of Arnold Cramer, continued the family business of operating a party boat out of Townsend's Inlet. He operated his boat, the *Captain Cramer*, from Van Sant's pier at 86th Street. This view shows the boat in its 45th year of business. The fare at the time was $3.

Capt. Don Cramer is shown in the cabin of the *Captain Cramer 2nd* in 1968. The operator of this 65-foot party boat, he continues the family business that began *c.* 1900. Always comfortable around the water, he was hired at age 14 by Capt. John Wilsey to serve on the Sea Isle City Beach Patrol because of his outstanding swimming ability. Recently, Cramer, who is now in his sixties, has been considering whether it might be time to end the family tradition of operating a party boat.

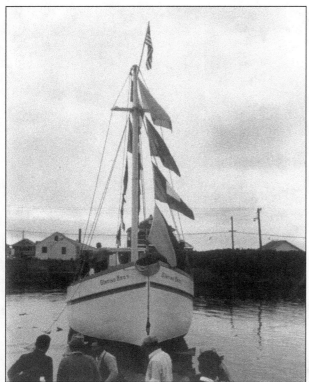

The D'intino brothers engaged in commercial fishing out of Sea Isle City for many years. Shown here is Tony Romano (third from left) and Pietro Pittaluga (fourth from left). This boat, a dragger, is shown on the day of its launching in the 1950s. During World War II, Sea Isle City commercial fishermen Ed Ward, Eli Sano, Dom Costantino, Dewey Monichetti, and John Monichetti rescued the crew of the Norwegian ship *Varanger*, which was sunk off the coast by a German U-boat.

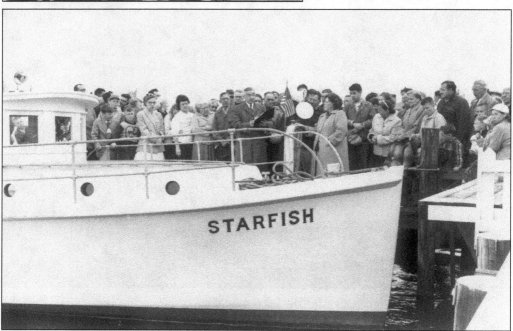

The *Starfish*, christened and launched in 1952, was another party boat that joined the growing number of such vessels at the time. It appears as though everyone in town is at the dock. Judging by the heavy clothing they are wearing, the day must have been a cold one.

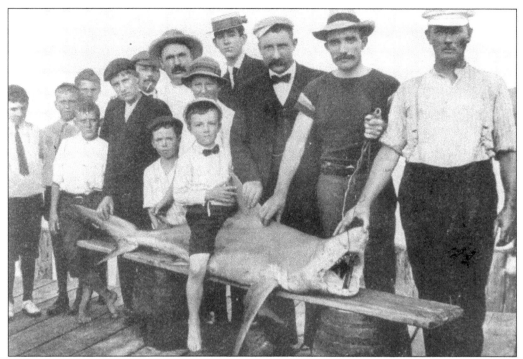

It looks as if this young lad could use a saddle as he rides this shark. This *c.* 1910 photograph shows an interesting mixture of formal and informal dress. The bow ties, even then, must have been somewhat out of place at this dock.

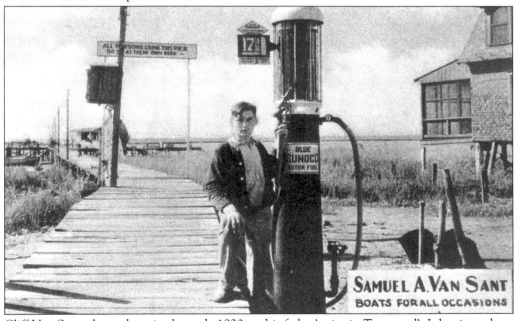

Cliff Van Sant, shown here in the early 1930s at his father's pier in Townsend's Inlet, is ready to pump gas for boaters anxious to begin a day of fishing. In those years Van Sant's pier was a favorite of the young people, who would dive from the pier and spend many happy hours in the bay.

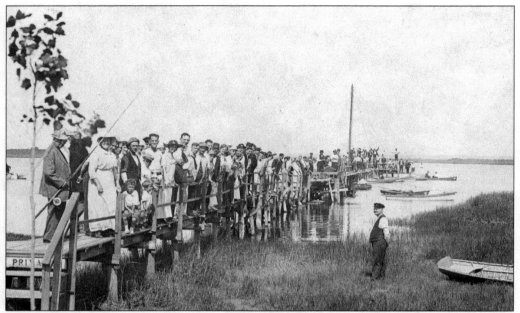

This c. 1900 scene shows the Townsend's Inlet Yacht Club. The occasion must have been something special to bring such a huge crowd of fishermen to the pier. Note the straw hats worn by some of the men and the sun-protecting hats adorning many of the women.

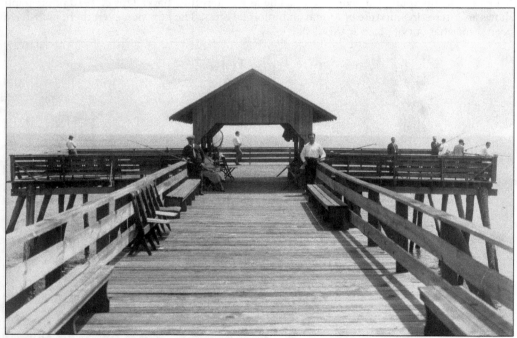

This c. 1920 view shows the far end of the fishing pier extending out from the beach between 41st and 42nd Street. It is the beginning of a great day for the anxious fishermen, who cast their line out into the ocean. Standing on the end of the pier gave one the feeling of being aboard ship, particularly at high tide when the waves pounded the poles below.

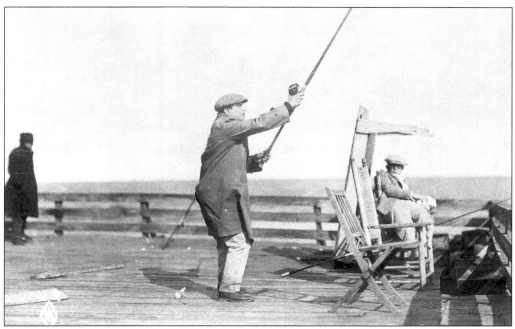

On a windy day, a sport fisherman casts his line out into the Atlantic Ocean *c*. 1920. The deck chairs look inviting even on such a cold day. During an extreme low tide, it was possible to walk out beyond this pier, which extended 300 feet from the boardwalk.

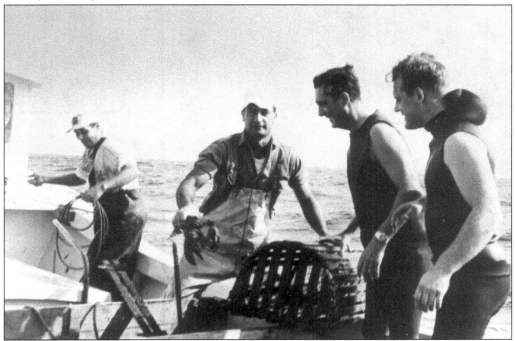

Judging by the smiles on their faces, these commercial lobster fishermen must have landed a good catch. Facing the camera, second from the left, is Lou Castaldi. Although commercial fishing had a lot of danger attached to it, many independent-minded men enjoyed the business.

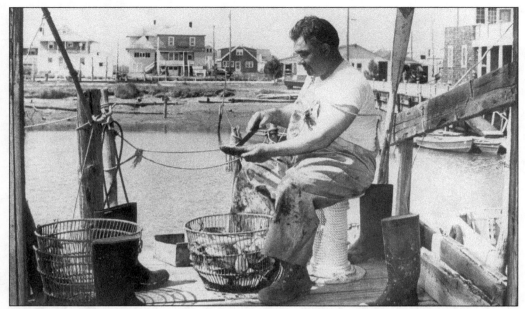

Manny La Rosa is shown shucking shellfish on the dock at 42nd Place *c*. 1940. His father, Pasquale La Rosa, started the Pound Net Fish Company in 1939. Joe and Pat La Rosa were also in business with their father. The pound boat used at the time, the *Mario*, was built by Stephano Libro and his son G.B. "Dan" Libro right in the driveway of the La Rosa home on Park Road.

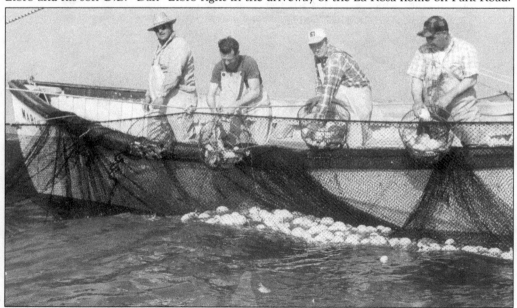

Shown *c*. the 1940s are, from left to right, Pasquale "Pat" La Rosa Jr., Alvin Fean, George Shoemaker, and Manny La Rosa. The boat is the La Rosa pound fish boat, the *Mario*. The fisherman are hauling in the nets with the day's catch, which would then be crated in ice and shipped to wholesalers. In the 1980s, Pat La Rosa Jr., along with his sons Charles, Joe, and Bill, attempted to begin a pound fish company. The effort failed due to the lack of fish inhabiting the offshore waters. Alvin Fean's family ran the Fean Hotel on the boardwalk for many years.

38

Four

BUSINESS AND INDUSTRY

At the time of Sea Isle City's inception, Charles K. Landis arranged for railroad service directly into town. Although numerous railroad companies merged or fell by the wayside, the resort had uninterrupted service into the mid-1930s. Rail passengers continued to arrive in Sea Isle City until the 1970s by bus, which served as a link to Ocean City, where trains continued to arrive.

With the rapid growth of the resort, a golden opportunity for business development also evolved. Sea Isle soon developed its first bank, a laundry service, magazine and novelty stores, bakeries, a coal and lumber yard, grocery stores, and a hardware store. These and many more such enterprises were in service c. 1900. Being a tourist town, Sea Isle needed good restaurants, many of which were provided by the hotels around town. Other restaurants operated independently.

An additional style of conducting business in Sea Isle City was the huckster who would bring in from offshore delicious Jersey tomatoes and a host of other vegetables and fruit. It was a common sight to see women out by the street purchasing such produce. The iceman was another daily visitor who, along with the milkman and the bread man, served as a lifeline for so many residents. The Sea Isle City Ice Company, owned and operated by the Romano family, currently serves much of South Jersey.

It was not until the 1940s that much of what is described above started to change. Refrigerators then became more common, eliminating the need for daily ice delivery. Chain food stores opened, and housewives switched to buying vegetables, milk, and bread there.

Unquestionably, a certain charm went along with the old way of doing things. This was missed as Sea Isle moved on under the banner of progress. People who were children growing up in earlier days have fascinating stories to tell about those times. They recall tagging along with Mom as the huckster pulled up. If the old farmer was in a good mood, he might give them a peach or some other treat. The bread man was always welcomed. He had large wooden boxes in which he carried his baked goods to the homes. Often the kids would spot an empty box on or by the truck and immediately convert it into the best canoe that one could imagine. Those really were the days.

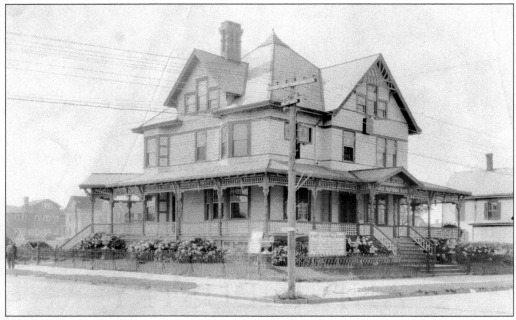

This *c.* 1905 view shows the home built by Morris Boney that later housed the First National Bank at the corner of 43rd Street and Landis Avenue, where the First Bank of Sea Isle City is currently located. The house was eventually moved to the adjacent lot and was purchased by Gar and Mary Gibson. They renamed it the Plaza and rented out rooms. Anna Schmidt and Mazie Delaney had a novelty store on the ground floor for many years.

Carolyn Cronecker, shown here, bought the Bellevue Hotel with her husband, Fritz, *c.* 1890. After her husband died in 1895, she continued to manage the hotel until her death in 1927. Her sons continued the business and eventually her granddaughter Margaretta Pfieffer ran it. Later, the hotel was sold to the Giampietro family. It was located at 40th Street and Landis Avenue.

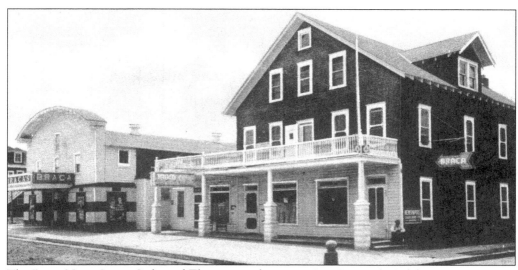

The Braca News Store, Café, and Theater are shown c. 1942. Lou and Madeline Braca came to Sea Isle City in 1901 and opened a barbershop at the above location, 41st Street and Pleasure Avenue. The Bracas continued to expand the businesses through the years. They had nine children and many of the descendants continue to be active in the town. Currently, their granddaughter Angel Dalrymple is Sea Isle City's first female commissioner. Shown below is a copy of Louis Braca's 1911 fruit and vegetable business license, which cost the princely sum of $5. The license was donated to the Sea Isle City Historical Museum by Harry Tracey, who married Rita Braca.

CAPE MAY COUNTY STATE OF NEW JERSEY

City of Sea Isle City

This License Entitles _____ *Louis Braca* _____

to ____ *Sell Groceries, fruits & Vegetable* ____ at ____ *Oceanside & Pleasure Rd.* ____

in the CITY OF SEA ISLE CITY, for one year from the first day of July, 19*11*, to the 30th day of June, 19*12*,

inclusive, and no longer, in accordance with the provisions of Ordinance No. 12, entitled "An Ordinance govern-

ing, regulating and fixing fees of Mercantile Licenses and regulating business licenses," approved May 16, 1908.

Received Fees $ *5.00*

In Testimony whereof I have hereunto set my hand and affixed

the seal of said City this ____ *30th* ____ day

of ____ *March* ____ A. D. 19*12*

____ *Frank W. Foster* ____ City Clerk.

____ *Lewis Steinmeyer* ____ Mayor.

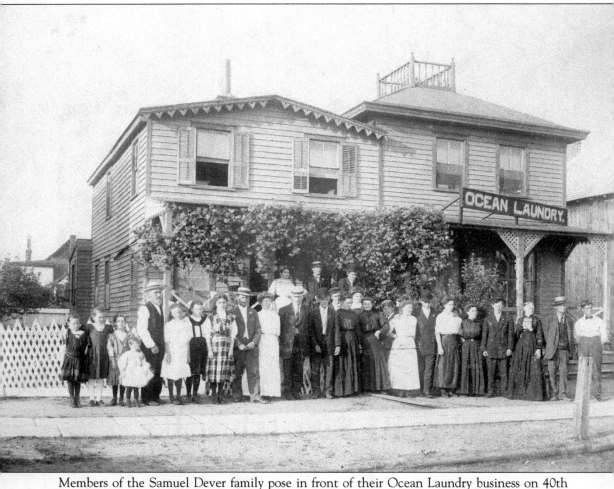

Members of the Samuel Dever family pose in front of their Ocean Laundry business on 40th Street *c.* 1900. Susan and Samuel Dever first purchased land in Sea Isle City in 1882. They had many children and have numerous descendants living in Sea Isle City today. The building still exists.

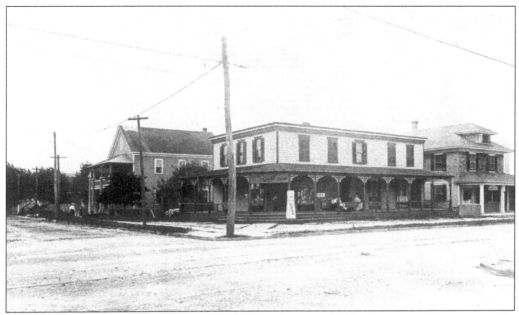

Maiswinkle's Candy Store and Rooming House is shown *c.* 1900. The store sold penny candy, which was always a hit with the children. A tailor shop is shown on the right. This is the present location of the Sea Isle City Historical Museum.

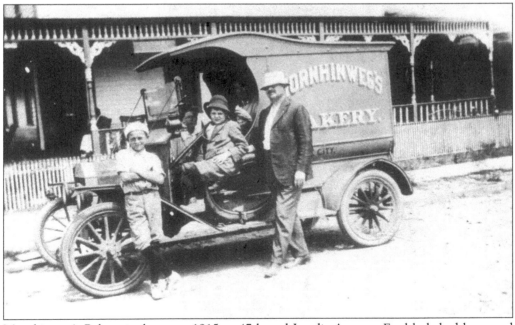

Mornhinweg's Bakery is shown *c.* 1915 at 47th and Landis Avenue. Freshly baked buns and pies were on sale each morning. An old-fashioned soda bar was a feature attraction in the store. Shown standing with his father is Gus Mornhinweg, who helped with bakery deliveries.

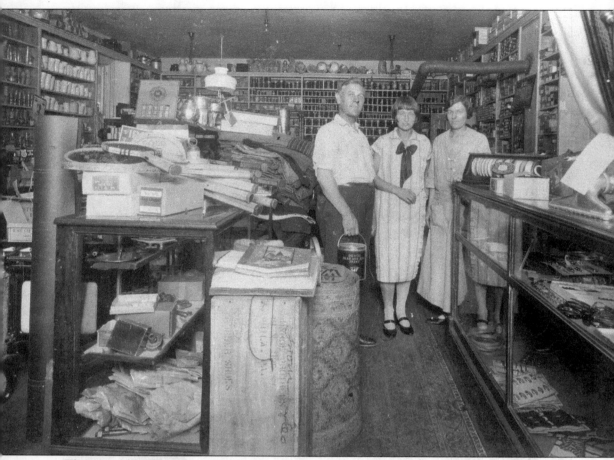

The original Pfeiffer's Department Store is shown *c.* 1915, with Clarence Pfeiffer, left, Margaretta Pfeiffer, and Minerva "Minny" Cronecker Pfeiffer. The Pfeiffers later expanded the business by adding the large building next door. The building that is shown, 4208 Landis Avenue, is the present Sea Isle City History Museum. The Memorial Garden behind the museum is dedicated to the Pfeiffer, Cronecker, and Rock families.

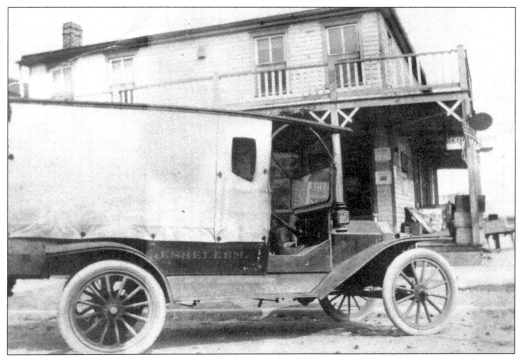

Shellem's truck is shown c. 1910 outside the Shellem general store at 85th Street and Landis Avenue. Until several years ago, the store contained the post office that served all of Townsend's Inlet. Blitz's Market does business here today.

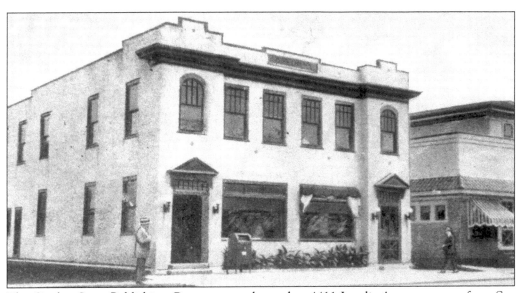

The Garden State Publishing Company was located at 4411 Landis Avenue, across from Sea Isle City Hall. The Haffert family sold the building in the late 1980s, and the new owners remodeled the structure. It seems that at one time or another, almost everyone in town was employed at the publishing company, which is pictured here c. the 1930s.

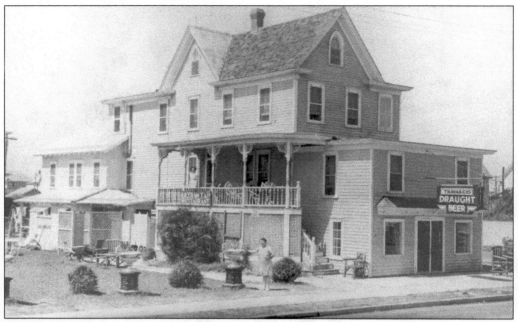

Travascio's Italian Restaurant, shown c. the 1930s, was located at Pleasure Avenue and 43rd Street. Many of the town's social events were held here. Jack Gordon, who operated a large wholesale fish business in Sea Isle City, married Teresa Travascio, a daughter. The couple lived across the street, in the former home of Mayor Martin Wells.

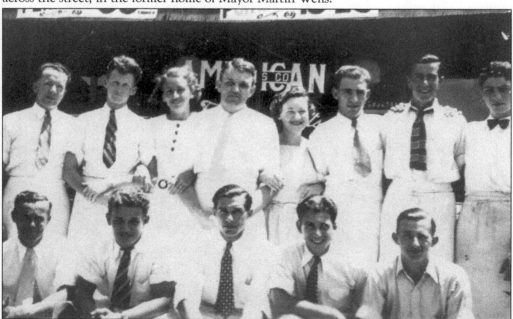

The American Store, shown c. the 1940s, was located at 43rd Street and Landis Avenue. In 1925, Leon Reardon, fourth from the left in the back, replaced George Neptune as manager. Reardon held the position for 35 years. Years earlier, the store became the Acme supermarket, which in 1958 moved to its present location at 63rd Street and Landis Avenue.

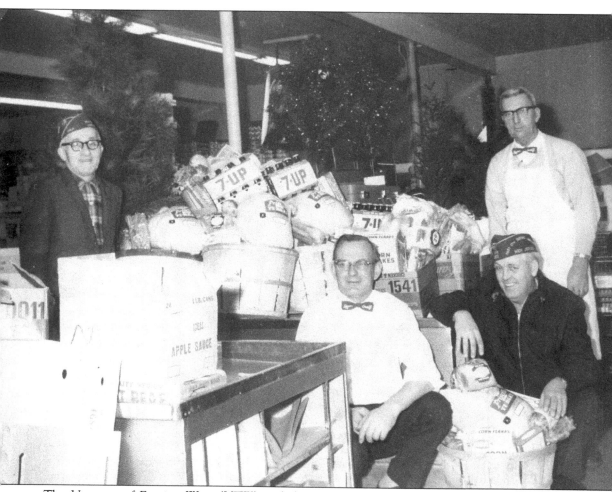

The Veterans of Foreign Wars (VFW) and the Acme supermarket work together as Santa Claus, distributing groceries to persons in need c. the 1960s. Involved in this annual project are, from left to right, Tom Travascio, VFW; Len Bonitt, Acme manager; Ken Rocap, VFW; and Howard Westcott, Acme employee.

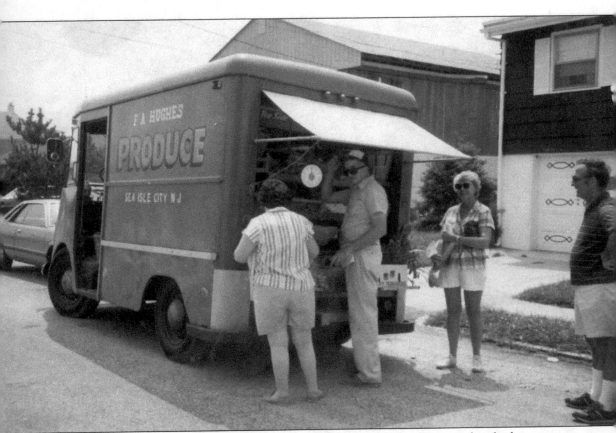

Fran Hughes, a jack-of-all-trades, is shown with his old blue huckster truck, which was once owned by Mr. Livingston, an earlier huckster. Huckstering was established as a tradition in Sea Isle City in the earliest days, back when Tom Jefferson began delivering ice. Hughes kept the tradition going for many a summer, bringing in fresh vegetables and fruits from offshore farms. A schoolteacher in the off-season, Hughes had as nice a way with his students as he did with the housewives who bought his produce.

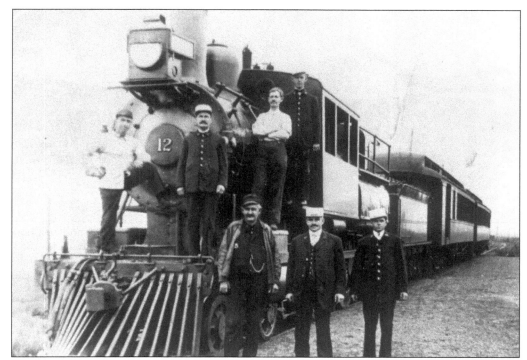

This view of the first Reading train to Sea Isle City and the local train workers was taken by photographer Albert Amberg. Amberg, whose photography shop was on the boardwalk, left a wonderful photographic legacy of Sea isle City in the late 1800s and early 1900s. His collection is available at the Sea Isle City Historical Museum.

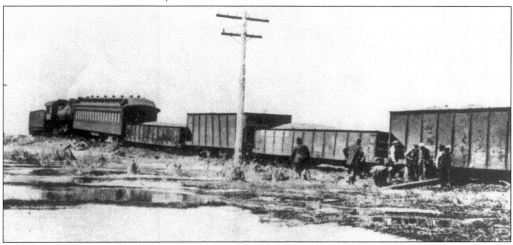

The train tracks over the meadow often flooded and washed out during high storm tides, making frequent track repairs necessary. This scene dates from c. the 1920s. A diary that was donated to the Sea Isle City Historical Museum refers to a severe storm in the late 1880s, soon after the track was completed. The entry, written by early Sea Isle summer resident Richard Atwater, said that the train was not running due to the flood tide and strong gale winds. So, Atwater had to crawl over the tracks from the Ocean View station into Sea Isle, a distance of about three miles, to reach his family vacationing on the island at the time.

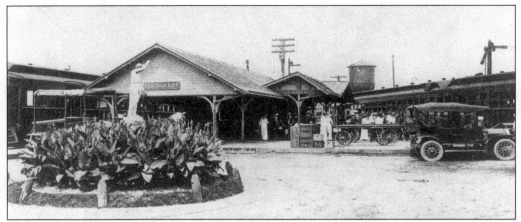

This *c.* 1900 view depicts a crowd arriving at Sea Isle City at the West Jersey and Seashore Railroad Station, located at 41st Street. Nearby was the lovely Depot Hotel, built in 1883. Notice the water tower in the rear of the photograph. Visitors flocked to Sea Isle to take advantage of special weekend excursions, daily excursions, and Sunday dollar fares. Today, this area is still the entrance to Sea Isle City but is now named Kennedy Boulevard.

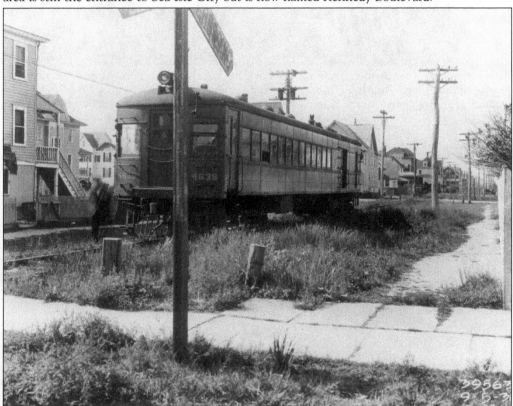

This 1934 photograph shows a Pennsylvania Reading Seashore Line car sitting at 43rd Street and Pleasure Avenue. It was common then to see a passenger leave the train along Pleasure Avenue and be greeted by a welcoming family. Soon afterward, the financially troubled railroad ceased operation and, during the early 1940s, the train tracks were removed.

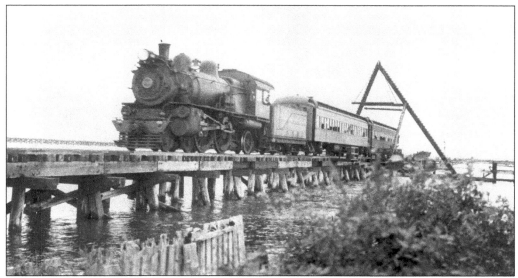

A Pennsylvania Reading Seashore Line locomotive crosses the Corson's Inlet (Strathmere) trestle during World War II, heading southbound to Sea Isle City. In the early 1930s, local high school students traveled to Ocean City High School by train on these tracks. Several student train tickets are on display in the Sea Isle City Historical Museum collection. The students rode on a "dinky" (diesel) single car. Conductors were Walter Sharp and Eugene Hallerin's father.

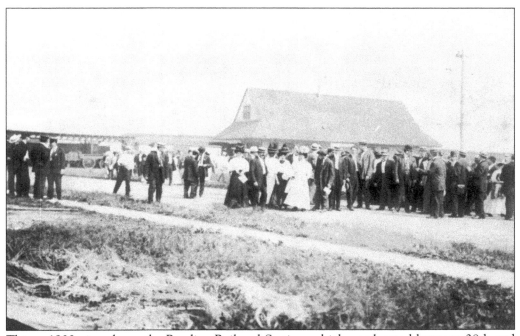

This c. 1900 view shows the Reading Railroad Station, which was located between 38th and 39th Streets. Some passengers have just arrived. Everyone appears to be stylishly dressed. Notice the bonnets on the women and the straw hats on the men.

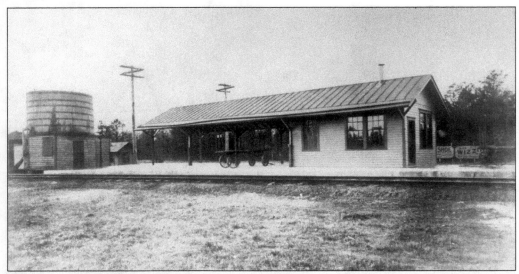

This station was located south of Woodbine, and it was here the train track divided. One track went southwest into South Seaville and then on to the Cape May Court House. The other track went southeast to Cemetery Station (just south of Corson Tavern Road) and then on to Ocean View Station, which was on Route 9 south of the 550 intersection. It then proceeded across the meadow into Sea Isle City. You can still see the raised railroad bed on the north side when going over the Boulevard into Sea Isle.

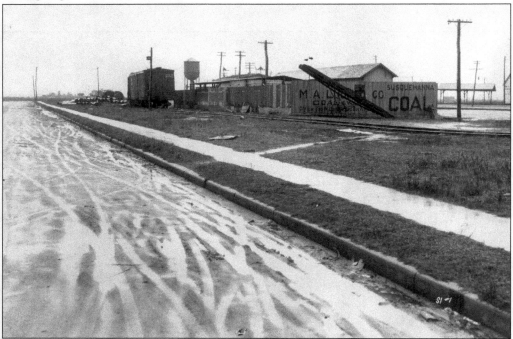

The Luongo Coal Company was located alongside the railroad tracks. Many houses were heated by coal, so this business was important to the town. Mike Luongo bought the Ocean Drive Hotel in 1939 and sold it to the Dogliotti family in 1946. Luongo's sister was Mrs. Davies, who married into the family that ran Davies Sunoco station in Sea Isle City.

This *c.* 1910 scene shows the Strathmere Railroad Bridge in the open position to permit boats to pass. In addition to serving the public for transportation, the bridge served as an ideal fishing pier, with very good fishing. When a train came, the fishermen would descend to the level below the tracks. After the train passed, they would return to the top and continue their fishing.

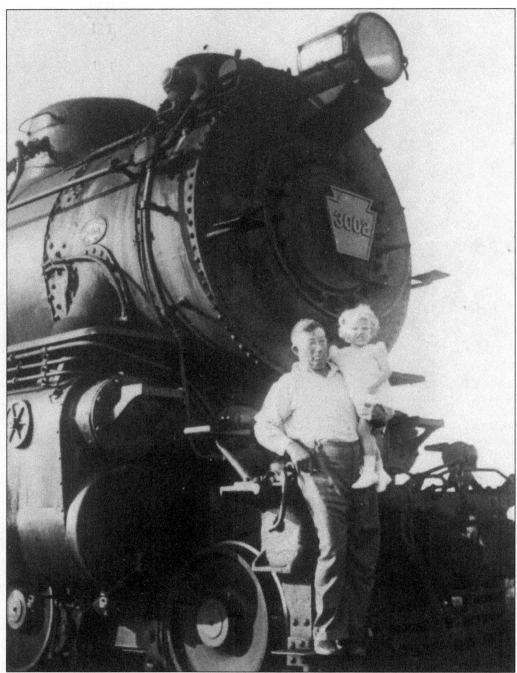

Shown is Henry A. Endicott holding his granddaughter Harriett Reardon c. the 1940s. Endicott was a track foreman from 1915 until his death in an accident at work in 1947. When the trains ceased operation in the earlier 1940s, the shed buildings were all moved or destroyed. Endicott moved a toolshed to his property at 205 44th Street to use as a garage and workshop. His daughter Myrtle Reardon, at 208 44th Street, also got a toolshed. Both of these sheds are still in place 60 years later.

Five

ORGANIZATIONS, CLUBS, AND PARADES

Sea Isle City has always had a conscientious, fun-loving, ambitious group of citizens making up the community. From the beginning, these citizens have recognized that in order for much of what they wanted to accomplish to happen—whether for a particular need or simply for enjoyment—an organization or some type group is practically a necessity.

Some of these groups are highly structured and, by nature, an integral part of the city. City government, police, firemen, and an ambulance corps are examples of this. They are part of the group of organizations that ensure public health and safety and the operation of the city on a day-to-day basis. Serving a different purpose, but just as essential to a "total" community, are groups and organizations formed to add an additional dimension of enjoyment to the community's day-to-day living.

Prime examples of this are the Women's Civic Club and the Sea Isle City and Townsend's Inlet Yacht Clubs. The Veterans of Foreign Wars organization also has enhanced living on the island.

In addition to ongoing organizations, clubs, and the like, various short-term groups have been formed. One spearheaded a fund-raising drive aimed at providing a hospital for the city. Others have arisen at various times to meet particular community needs.

The Prohibition years lasted through four presidents: Woodrow Wilson, Warren Harding, Calvin Coolidge, and Herbert Hoover—a total of 14 years. The Sea Isle City seacoast was an excellent route to run the contraband liquor, and thus the term rumrunner entered the local vocabulary. The Sea Isle City Historical Museum has two bottles of the illegal liquor found on the beach by Mike Monichetti in the 1990s.

However formal or informal, whatever purpose—practical or fun-oriented—it is safe to say that Sea Isle City's multitude of organizations and groups have always been the backbone of the community. Year-round and summer residents have always joined in whatever the goal or project to make things happen. Sea Isle City's traditional Baby Parades exemplify this most vividly.

SMILE-YOU'RE IN SEA ISLE CITY
Words and Music by EDDIE V. DEANE

SEA ISLE CITY

1882 ~ 1982

The Official Song of the City of Sea Isle City
CELEBRATING
100 YEARS OF PROGRESS
1882 — 1982
The Sea and Sand Vacationland

Shown here is the official song and logo of Sea Isle City. The town's centennial celebration in 1982 inspired a group of dedicated residents to begin plans for the formation of the Sea Isle City Historical Society. The efforts of this group resulted in much of the town's past being preserved for present and future generations.

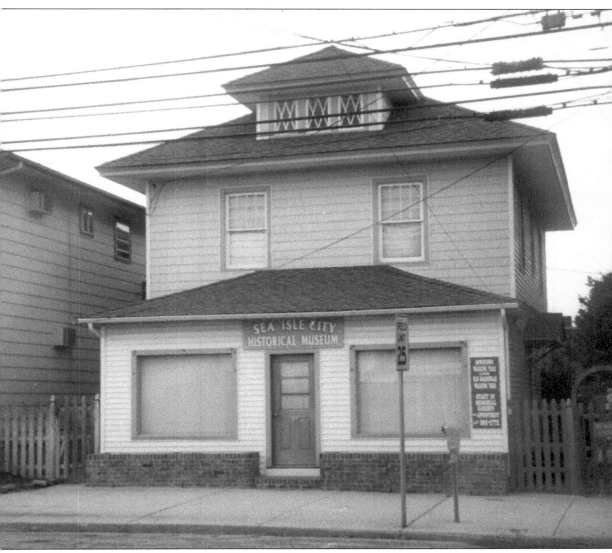

This view shows the Sea Isle City Historical Museum as it appears today at 4208 Landis Avenue. This old building was constructed c. 1914. It was once a home with a tailor shop in front. At another time, a dentist office was located on the second floor. Before moving to this location in 1995, the Sea Isle City Historical Society first used an empty classroom in the public school and later, an old garage behind Sea Isle City Hall, where memorabilia was on display. Behind the present building is the Memorial Garden, made possible by the Pfeiffer and Rock families and dedicated to the Pfeiffer and Cronecker families. The original Pfeiffer's Department Store was located in this building.

Mayors of Sea Isle City

Martin Wells	1882
Thomas E. Ludlam	1884
John G. Woertz	1896
August H. Sickler	1896
Thomas E. Ludlam	1899
James F. Sherry	1906
Bernard J. Quinn	1908
Lewis Steinmeyer	1910
Richard M. Atwater	1913
Richard W. Cronecker	1917
Irving Fitch	1919
Maurice M. Sofroney	1925
Earl M. Waddington	1933
G. Fred Cronecker	1937
William A. Haffert, Sr.	1945
Claude A. Van Hook	1956
Fred D. Sofroney	1957
Vincent L. Lamanna	1961
William R. Wilsey	1965
Dominic C. Raffa	1973
Michael J. McHale	1985
Leonard C. Desiderio	1993

Beginning with the first mayor and continuing to the present one, Leonard C. Desiderio, the city has been fortunate in having the leadership that is essential if a city is to survive and grow. Not listed, but sharing an equally important role are the Sea Isle City commissioners. Jim Iannone and Angel Dalrymple currently serve in that capacity and contribute much to maintain the town.

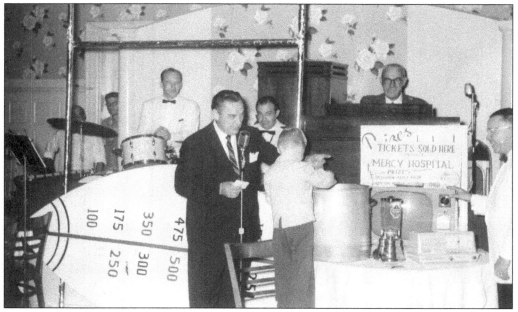

Commissioner Mike Gardner is shown at the microphone during a Mercy Hospital fund-raising drive c. the 1960s. Gardner demonstrated exceptional leadership skills as he assisted Mayor Vincent Lamanna in restoring the city after the 1962 storm that devastated the island. On the far right is Art Laricks, a prominent businessman who was county surrogate for many years.

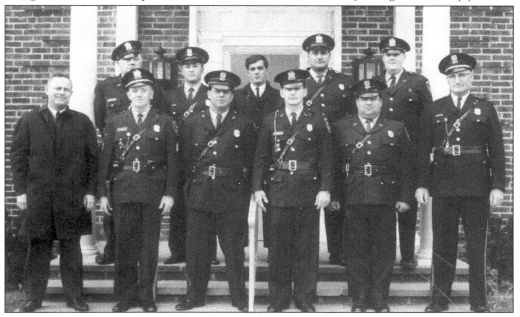

Sea Isle City's finest are shown here c. 1965. They are, from left to right, as follows: (front row) Police Commissioner Bill Wilsey, George Zizak, Joseph Pittaluga, Carl Gansert, Camille D'intino, and Robert Campbell; (back row) James Cauley, Jerry Ruttledge, Joseph Brezele, Pasquale La Rosa, and Joseph Makrai (police chief's son). Both Gansert and Campbell later served as chief of police.

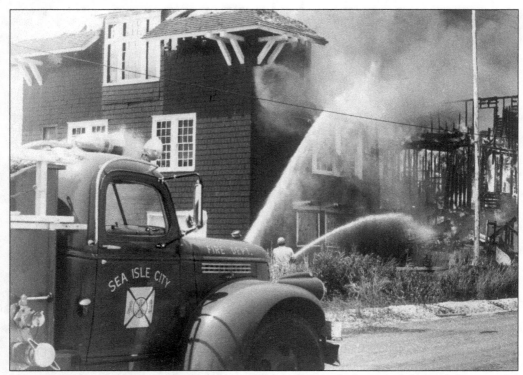

The original Sea Isle City Yacht Club was at 57th and Sounds Avenue. It burned down in the 1960s after having been converted into a private residence. Shown in both photographs are city firefighters attempting to keep the blaze from spreading. The fire could be seen throughout the island that day.

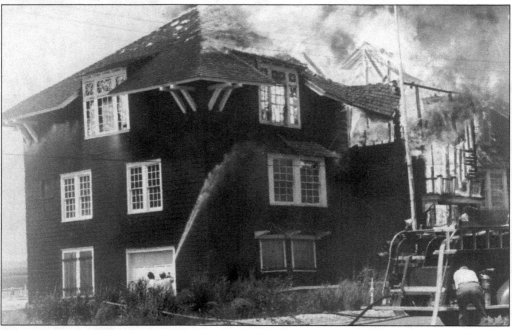

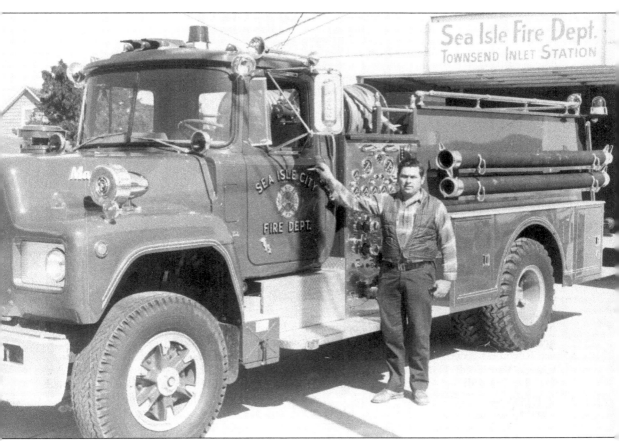

John Mazurie stands beside a fire truck in this *c.* 1960s image. Joe Davies was fire chief until the early 1970s, when he was relieved by Mazurie, who has served the city faithfully for over 30 years and continues to do so. The city has always been fortunate to be served by dedicated volunteer firefighters.

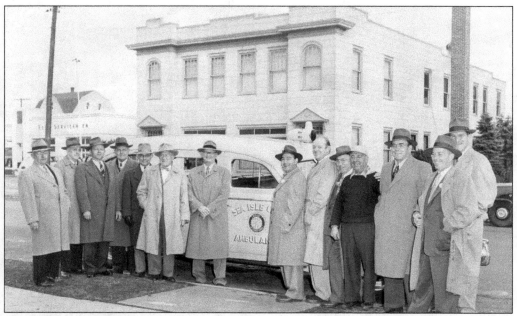

These men of the Rotary Club were behind a fund-raising drive to provide the city with a new ambulance *c.* the 1940s. The first ambulance was purchased in 1934. Pictured from left to right are Reverend Sawn, Adolf Wilsey, Willard Wright, unidentified, unidentified, unidentified, Claude Van Hook, Dom Raffa, Marty Van Hook, unidentified, Tony Canuso, Ira Bushay, Art Laricks, and William A. Haffert Sr. Nile R. Linn Sr. of the Sea Isle City Ambulance Corps died in an accident while on a call on July 15, 1972. He was 57 years old at the time. His daughter Phyllis Linn currently heads the Sea Isle City Ambulance Corps.

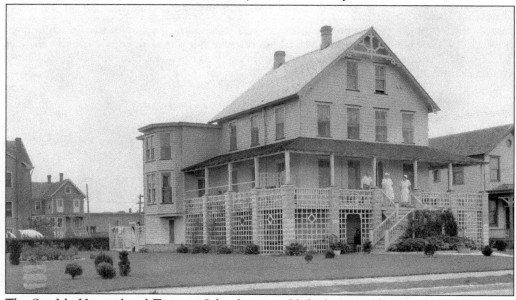

The Sea Isle Hospital and Training School was established in 1926 by Claude Van Hook for the care of convalescents, victims of nervous diseases, and backward children. Located at 48th Street and Pleasure Avenue, it was sold to the Sisters of Mercy in the 1950s.

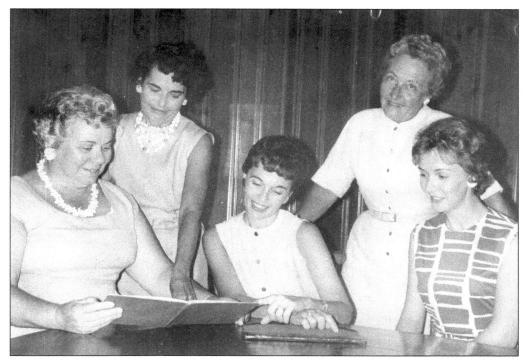

These industrious women are gathered to plan strategy for a fund-raiser for Mercy Hospital, located at 58th Street and Landis Avenue. From left to right are Helen Leaming, Mary Haffert, and Nancy Haffert.

Dr. Frank Dealy developed the 33-bed Surf Hospital, which was sold in 1953 to the Mercy nuns and renamed Mercy Hospital. The hospital was shut down in 1969. This view shows the hospital with an old-time ambulance parked out front.

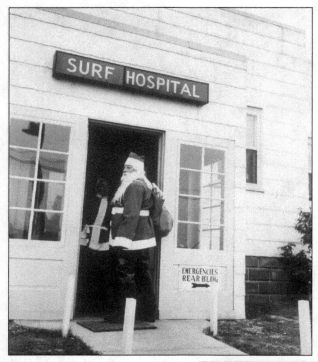

Santa Claus visited the hospital every Christmas, bringing gifts and cheer to all patients. Gus Cronecker and Mike Gardner were two of the Santas. Many babies were born in this hospital, one of them arriving during the 1962 storm.

Vince's Hoagie Shop, located at Kennedy Boulevard and Pleasure Avenue, was always the local hangout. Vince and Annette Mollo, proprietors, made everyone feel like family. This 1959 photograph shows, from left to right, Rocco Morano Sr., Vince Mollo, an unidentified person, Tony Galento, Pat La Rosa, and Mike Baldini. Currently the Epicurean Restaurant is located at this site. One of the regulars at Vince's was Rudi Plappert. During World War II, Plappert liked the look of the island that he saw while patrolling off the coast in a German U-boat. So, after the war he moved to Sea Isle.

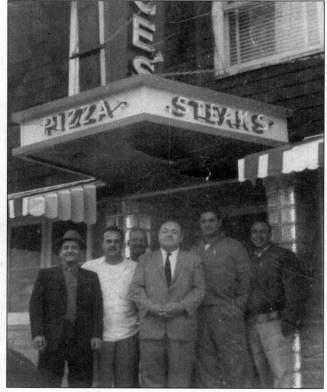

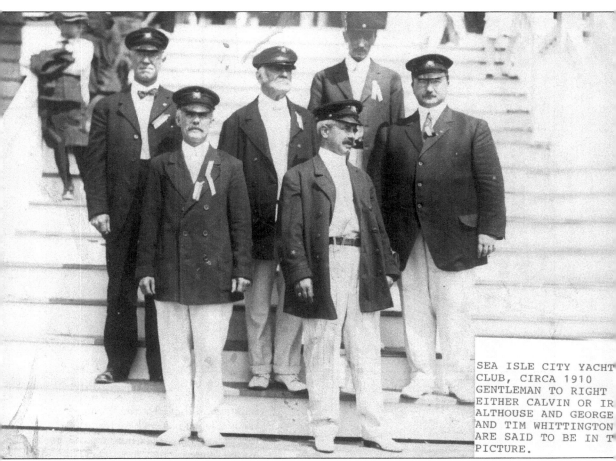

SEA ISLE CITY YACHT
CLUB, CIRCA 1910
GENTLEMAN TO RIGHT
EITHER CALVIN OR IR
ALTHOUSE AND GEORGE
AND TIM WHITTINGTON
ARE SAID TO BE IN T
PICTURE.

The Sea Isle City Yacht Club originated in 1888. There was every bit the enthusiastic interest in boating then as there is today. Huge crowds would gather here to watch and or participate in the day's events. The Yacht Club remains active currently in its Venicean Road location, where much of the activity centers around the youth of the community.

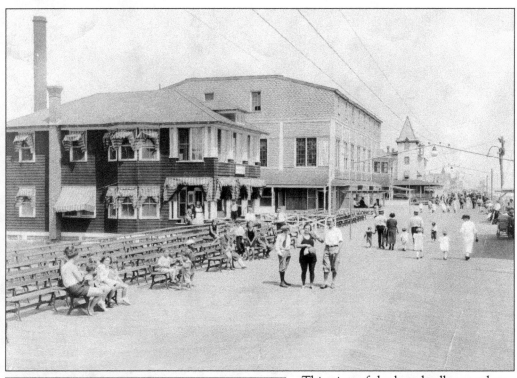

This view of the boardwalk was taken looking north c. the 1920s. The first building on the left is the Woman's Civic Club, a place where rest rooms, first aid, and plenty of hospitality were always offered. The famous Excursion House is the next large building. It was the site of sporting events, dances, and a variety of other activities, and its first floor held several stores. The building was destroyed in the 1962 storm.

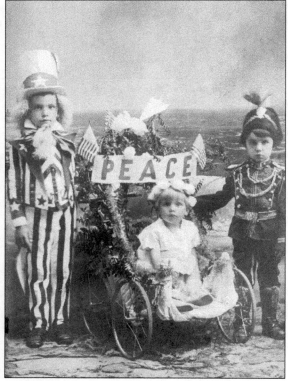

This c. 1915 view was taken during the annual Baby Parade. Held prior to World War I, the parade has Uncle Sam and the kaiser, showing that peace could unite the United States and Germany. Sadly, it did not turn out that way. The girl in the coach is John Mazurie's mother, with her brother to the right.

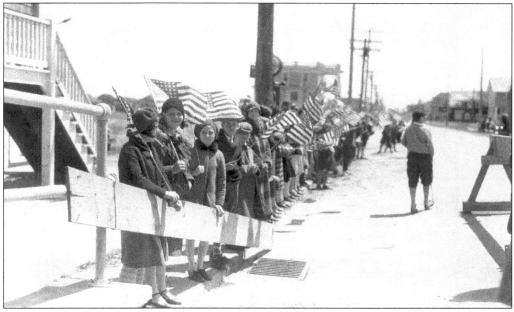

The 1927 Hale fire engine made its original grand entry in this parade in 1927. Three quarters of a century later, the same truck was still leading parades, driven by Homer Miller. Flag-waving spectators line the street in anticipation of the new fire engine making its way down the street.

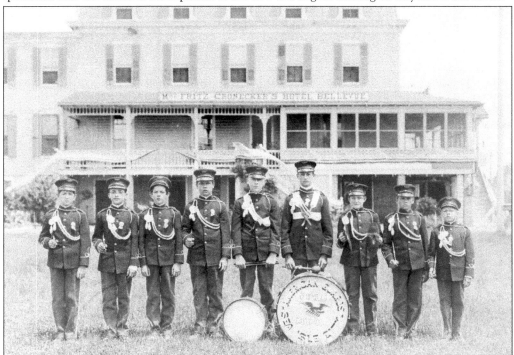

This group of young musicians gathers at the Hotel Bellevue. Called the Sea Isle City American Guards, the musicians look very serious as they prepare to present a program. They must have been quite warm in their band uniforms on this summer day in the 1920s.

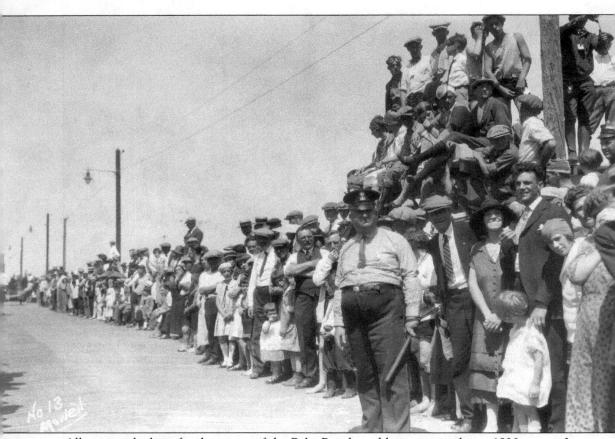

All eyes are looking for the queen of the Baby Parade and her court in this *c.* 1920s scene. It must have been a lovely day. Notice the umbrella shading the young woman along the side. Most individuals in the crowd appear to be dressed somewhat formally. The police officer does not seem to be having any crowd-control problems.

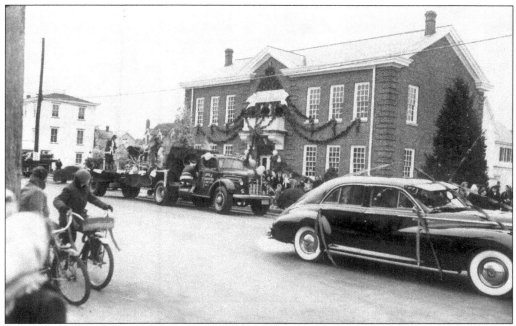

The annual Christmas parade is under way. The boys following along on their bicycles are enjoying themselves. Notice how elaborately Sea Isle City Hall is decorated. This c. 1940s scene is no different than that of today. Winter or summer, crowds always turn out for these fun-filled events. Dedicated in 1906, city hall has served the town for nearly a century.

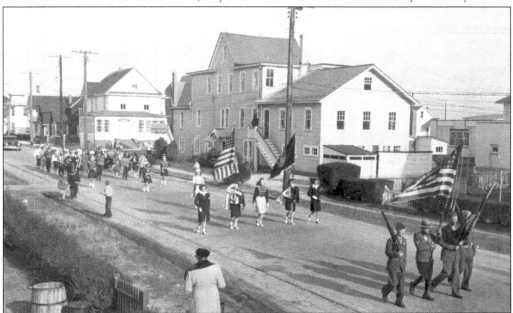

In this Christmas parade c. the 1940s, a marching band led by the color guard proudly moves along Pleasure Avenue. The building on the opposite side of the street was formerly called Travascio's Restaurant and Bar. It is now called the Springfield and is a popular spot in the summer.

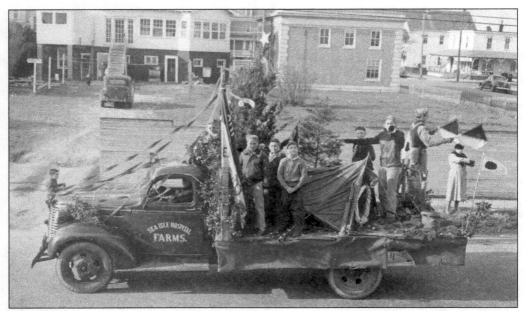

These Boy Scouts are eager participants in the parade. They are riding on the Sea Isle City Hospital truck. The hospital was owned by Claude Van Hook. The scene shows Pleasure Avenue just south of 42nd Street. The automobile parked behind the house looks like a survivor from those used during World War II—a time when drivers made due with whatever they had for the duration of the war.

Mayor William A. Haffert Sr. participates in the annual Baby Parade on the boardwalk c. the 1940s. These parades, a highlight of the resort's summer activities, began in 1916. They are a tradition that continues today.

The Fehrle family came to Sea Isle City in 1905 and operated the Candy Kitchen and Bowling Alley. Family members still live and work in town and continue to contribute to the community. Everyone misses Herman Fehrle, a volunteer fireman and a mason by trade. His son Roger Fehrle continues to operate that business. This scene is a re-creation of the "old family business" used in a parade.

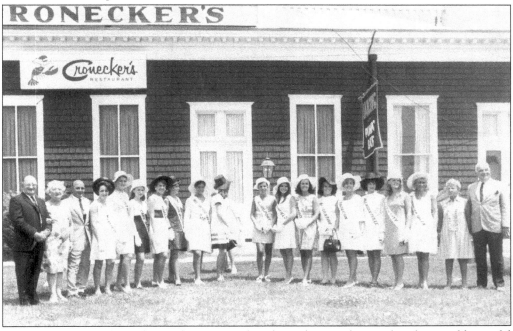

Sea Isle City was along the Hydrangea Trail and was known for its abundance of beautiful flowers. Miss Hydrangea, in this scene, was Pam McCowley. The celebration was held at Cronecker's Rathskeller. Lou and Mary Mutzel are shown on the left with Mayor Dom Raffa beside them. Mae and Graham Berry are on the right.

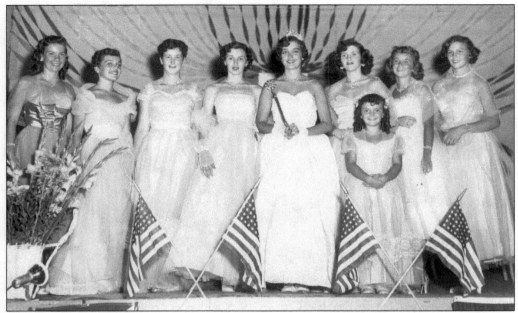

The queen of the Baby Parade is Cathy Tarese, shown with her court c. the 1950s. Eileen Lamanna is the girl mascot. Her father, Chel Lamanna, was killed in World War II. The winners of these Baby Parade contests were chosen by counting the votes that were placed in glass jars throughout town. Each vote cost 10¢.

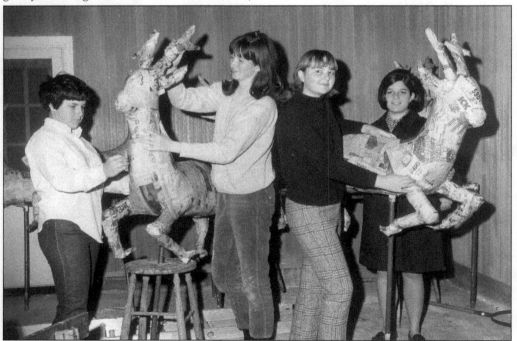

These talented young women are busy planning the Christmas parade of 1970. They are, from left to right, Cecile Dever, Mary Lou Hughes, Cathy Crisp, and Anne Hogan. The antique auto parade is also a tradition, currently headed by Gerard Desiderio, a dedicated community worker.

Six

BY THE BEACH

Sea Isle City is first and foremost a resort town. As such, the focus has always been on the island's lovely beaches and, of course, the ocean, which provides the town with such a marvelous climate. Thus, for years the town has been known as the "Sea and Sand Vacation Land."

In the 1880s, lifesaving stations were set up at 33rd, 57th, and 85th Streets. The men who manned these stations saved the lives of many sailors. In that time period, Life Saving Stations Nos. 33 and 34 were positioned along Ludlam's Island, currently Sea Isle City. Such stations could be found every three miles along the entire coast.

It was not until 1919 that the Sea Isle City Beach Patrol originated. Its function was to protect bathers, who were coming to the resort in increasing numbers each summer season. John Coleman was the first lifeguard captain, holding the position from 1919 to 1922. In addition to their beach protection activities, the Beach Patrol has provided the resort with the annual Lifeguard Races, which always draw large crowds to observe these boating and swimming competitions. The annual Lifeguard Ball has proven to be a popular event through the years. Both the old Surf House and the Excursion House have hosted these annual balls.

The boardwalk was built early in the century. It was washed away in 1928 and was reconstructed in the early 1930s. This cycle of washouts and reconstruction has continued through the years. After the 1962 storm, a more permanent macadam-topped promenade was built, and it still remains in place today.

The merry-go-round was a favorite attraction until it washed away in the 1962 storm, along with the Madeline Movie and Fishing Pier. Visitors have always found it to be inviting to stroll the boardwalk, stop at one of the many refreshment stands or stores along the way, and take in the beautiful view of the Atlantic Ocean.

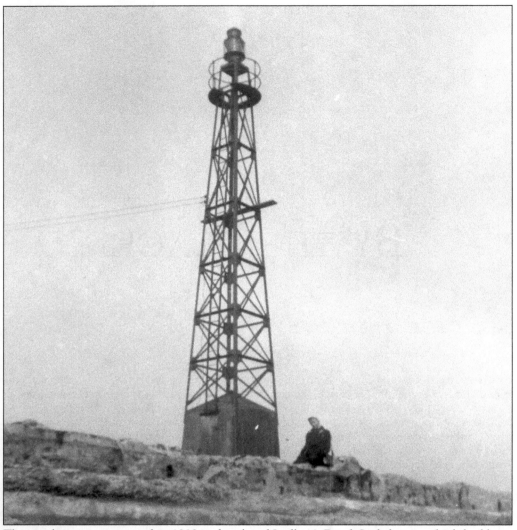

This steel tower was created in 1923 and replaced Ludlam's Beach Lighthouse, which had been erected in 1885 at 31st Street and the beach. The tower provided a warning light to ships at sea. Following the 1962 storm, the remains of the steel tower were removed.

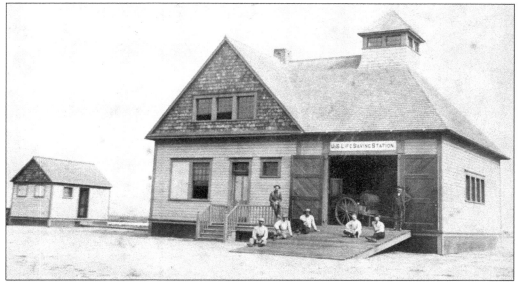

Many ships have been wrecked off the coast, prompting the federal government to erect lifesaving stations along the coast. In the early days, crews stayed on the mainland and were alerted by the firing of a gun. They would then hurry to the island to save the shipwrecked sailors. In 1880, the first captain and crew lived on the island for nine months of the year.

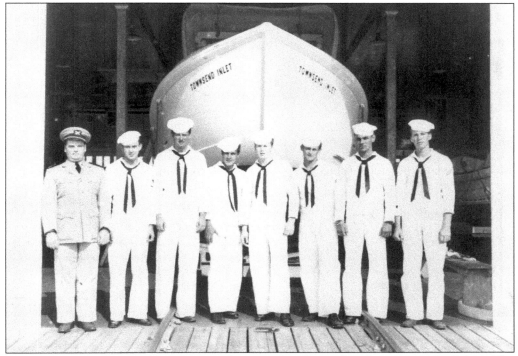

A Coast Guard officer and his crew are shown with a Coast Guard cutter as a backdrop. The Coast Guard followed the earlier lifesavers. Many Coast Guard crewmen were stationed in Sea Isle City throughout World War II. Several met the girl they would marry and later settled down in town.

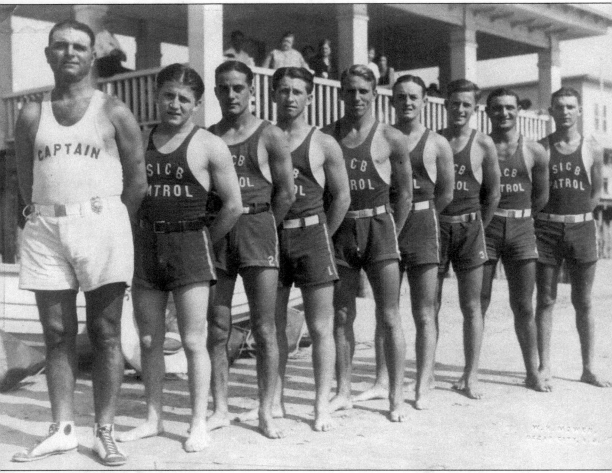

Shown here is Capt. "Jumbo" Cannova with the Beach Patrol *c.* 1930. Future Capt. "Johnny" Oakes is shown fifth from the left. How did such a small patrol protect the beaches? The Sea Isle City Life Guard Patrol began on a paid basis in 1919. Following is a list of lifeguard captains over the years.

1919–1922 John Coleman
1923 D. Duross
1924 Edward Stevens
1925–1937 Jumbo Cannova
1938–1944 Johnny Oakes
1945 Capt. Walter Holmes*

1946 Joseph McSorley
1947–1955 John Wilsey
1956–1964 Bill Wilsey
1965–1969 Joe Bowen
1970–1977 Bill Gallagher

1978–1981 Tom McCann
1982 Mike McHale
1983–1984 Tom McCann
1985 Stu Bakely
1986–present Warren Steele

*Walter Holmes was a guard who served because the war was on and there was no one else to do the job.

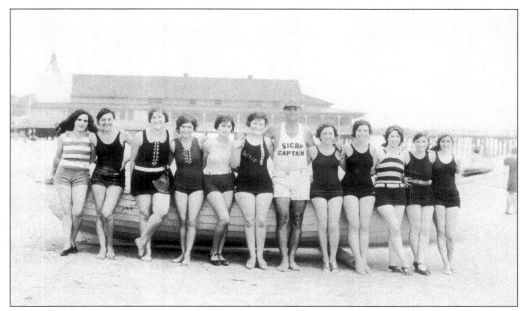

Capt. "Jumbo" Cannova is shown here with a group of young women *c.* 1930. Does this scene depict some of the trials and tribulations of a beach patrol captain? Bathing caps were common back then. Notice the third girl from the left with a cap hanging from her belt.

Bill Gallagher, captain of the Sea Isle Beach Patrol from 1970 to 1977, is shown at a Lifeguard Ball in the 1970s. The patrol grew in cohesiveness and professionalism under his command. In 1970, the patrol was divided into three beach zones, with a lieutenant assigned to each. He initiated the "rookie school," and guards were certified in cardiopulmonary resuscitation. For the first time, both the first guard to a rescue, plus the backup guard each were required to carry a can (rescue buoy). Communications were improved between stands and headquarters. Gallagher, one of the finest swimmers in the history of the guards, initiated the Island Run, which was suggested by Kevin McKee.

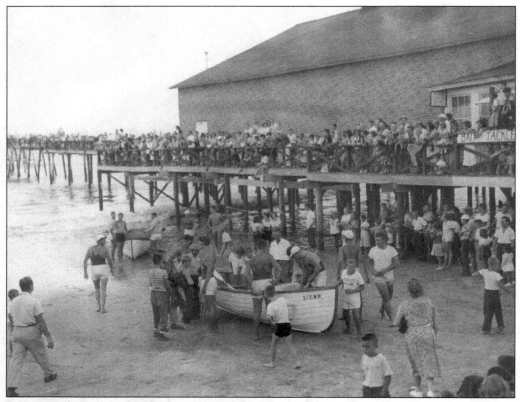

Spectators line up to watch the Lifeguard Races, which have always been exciting events to observe. This is a rowing race just coming to a close in the early 1940s.

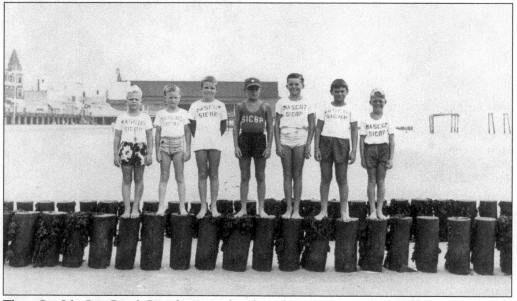

These Sea Isle City Beach Patrol mascots lined up along the jetties are a big help to the guards on duty. Off duty, the lifeguards would often hold "school" for these aspiring lifeguards.

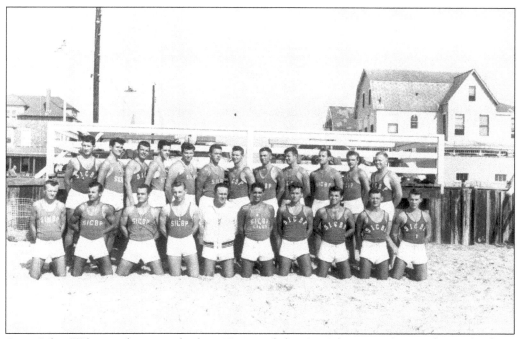

Capt. John Wilsey is shown *c.* the late 1940s with his Sea Isle City Life Guard Patrol, whose ranks have grown compared with the earlier patrols. Jack Gibson, New Jersey state assemblyman, is second from the left in the front row, and Dr. Joseph Giordano, a retired dentist, is fifth from the left.

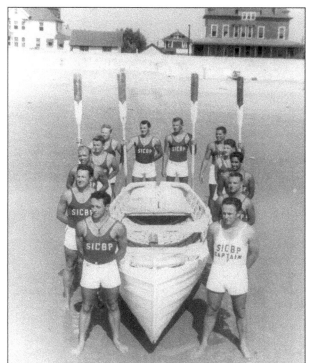

In this *c.* 1950 photograph, Capt. John Wilsey is shown with the Sea Isle City Beach Patrol. His brother Bill Wilsey, a future lifeguard captain, is fifth from the left.

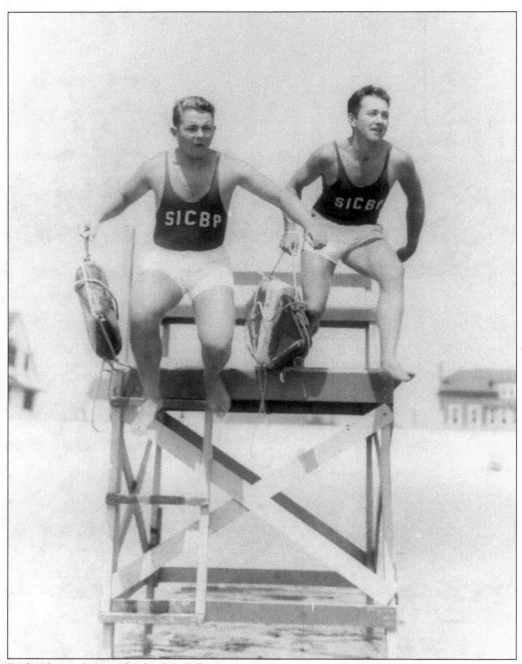

Dick Clancy, left, and John McCall reenact a rescue run in the 1940s. Although there have been many changes in rescue procedures during the 50 years since these photographs were taken, much still remains the same.

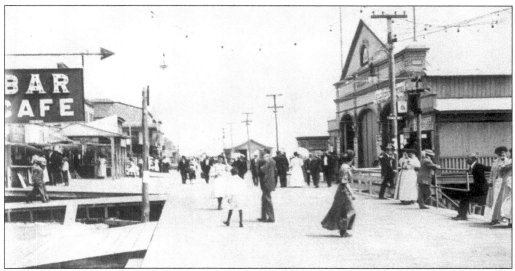

This *c.* 1900 view shows the summer crowds enjoying a leisurely stroll on the boardwalk. Note the formality of dress: the men are in suits and straw hats, and the women are in long gowns, heels, and fancy hats. The ocean pier is visible on the right. It was badly damaged in the 1944 hurricane and was totally demolished in the storm of 1962.

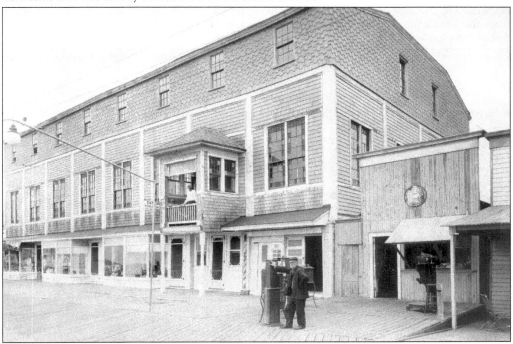

The Excursion House was one of the most unique buildings on the Atlantic Coast. Constructed in 1882 by the Landis family, the building was three stories high and included a hardwood roller-skating rink on the ground floor. The second floor was an observation deck and the top floor was a huge ballroom, where dancing, talent shows, and prizefights took place. It was from here that spectators would watch the multitude of activities taking place on the beach. Motorcycle races are an example.

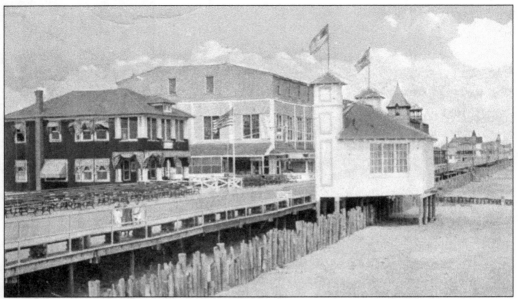

This scene from the early 1900s shows the Women's Civic Club, the famous bandstand, and the Excursion House. The Women's Civic Club, the oldest organization on the island, originated at the turn of the century. Crowds would gather here to dance to the music coming from the bandstand. Notice the benches for spectators. Lifeguard Balls were often held in the Excursion House.

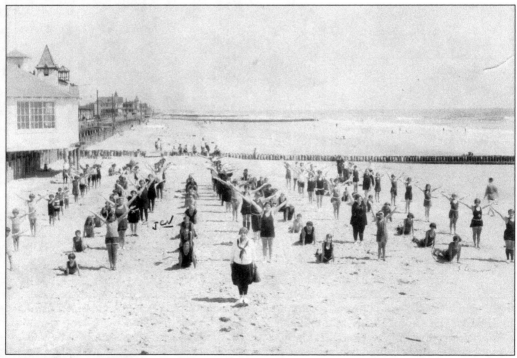

Just as today, physical fitness was important in the 1920s, as shown by this large exercise group on the beach at 41st Street.

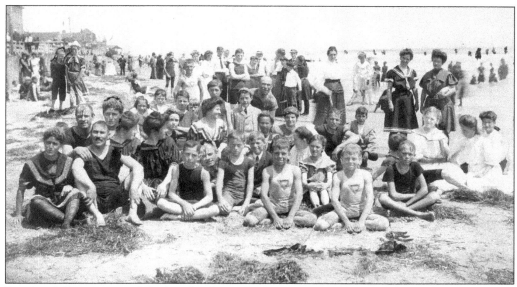

People of all ages enjoyed the beach, always the main attraction in Sea Isle City. In this c. 1910 scene, the women's bathing suits, in particular, appear to be cumbersome. Suits made with wool must have been quite itchy.

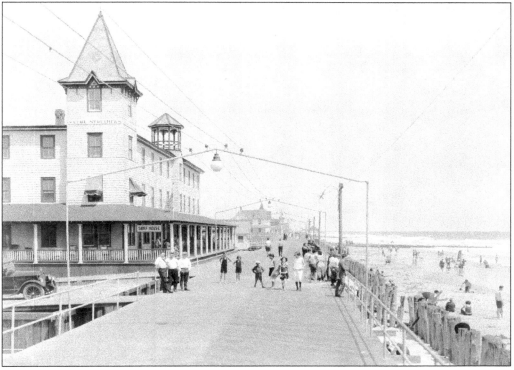

Members of the Struthers family owned the Surf House c. 1930. Imagine sitting on that front porch rocking away the hours with that beautiful ocean view. The Surf House was later purchased by Dr. Frank Dealy, who intended to convert it to a hospital. The 1944 hurricane had other ideas and washed it out to sea.

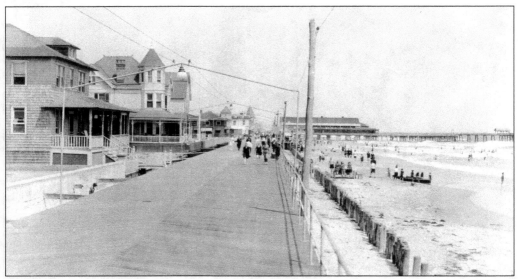

The boardwalk at one time extended from 20th Street to 63rd Street. It became narrower at each end. It was rebuilt frequently after major storms. The present promenade is constructed on top of a dune line pumped in after the 1962 storm. It is reinforced with boulders and the surface is blacktopped. Although some people miss the old boardwalk, they do not miss the splinters. This view dates from c. the 1930s.

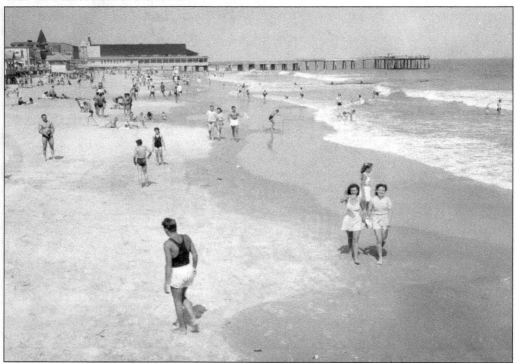

Beachgoers c. 1940 enjoy their day at the uncluttered beach, with the old fishing pier as a backdrop. The pier was originally called the Ocean Pier, later the Cini, and in 1940 it was purchased by the Braca family and named the Madeline in honor of Mrs. Braca.

Seven

COASTAL STORMS

Living on an island such as Sea Isle City has many advantages. However, when the ocean acts up and the waves come crashing onto the island, it is difficult to remember the benefits of the resort.

Severe storms have taken their toll on Sea Isle City. According to reports, so much beach had eroded in the 1890s that peatlike marshes were exposed, and on those marshes the hoofprints of horses that had galloped across the island in much earlier days were revealed.

In the 1920s, another serious storm, a northeaster, ripped the coastline, tearing up the railroad tracks and doing much damage to the boardwalk. The 1944 hurricane ranks as one of the worst storms, causing more damage to homes, property, beaches, and the boardwalk than any previous storm.

The storm of March 6, 1962, tops them all in terms of duration and damage. This storm was brought about by a series of conditions involving the sun, moon, tides, wind, and pressure system. During a three-day period, the storm caused peril along the Atlantic Coast from Florida to Maine. It was appropriately categorized as a 100-year storm. In Sea Isle City, just about every beachfront home was either destroyed or seriously damaged. Due to the severe repeated high tides, similar damage occurred to property throughout the resort, causing the need to evacuate everyone, excluding men needed to assist with the emergency. The causeway leading out of town was washed out, and helicopters were used in the evacuation of the town. Most of those who left could not return for almost a week, only after some semblance of order was restored to the city.

The true fiber of the community was put to the test at this time—not only in persevering through the storm but also in joining together to restore the community to a livable condition. This being accomplished, they made ready for the summer season. These tasks were completed, and summer visitors were able to enjoy their vacation as in years past. Once more the townspeople were put to the test and showed what remarkable character they had in this successful restoration effort.

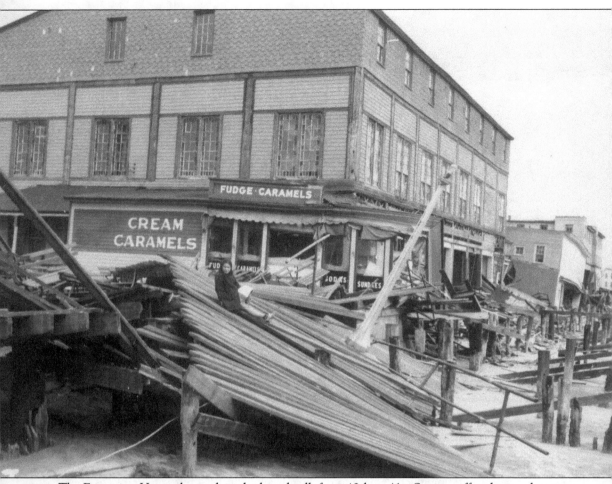

The Excursion House, located on the boardwalk from 40th to 41st Street, suffered some damage to the boardwalk-level stores, such as Vatso's Restaurant on the corner, advertising cream caramels. Vatso's lemon blends were popular in the 1940s and 1950s. This scene shows the boardwalk having been ripped up by wave damage during the 1944 hurricane.

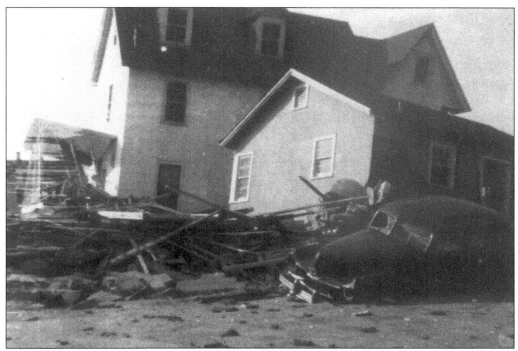

This was the scene of the aftermath of the hurricane. These homes and an automobile were left in sad shape in 1944. Residents are always faced with the thought of what the next severe storm might bring. The dune pumped in after the 1962 storm has given the island some added protection that it did not have in earlier days.

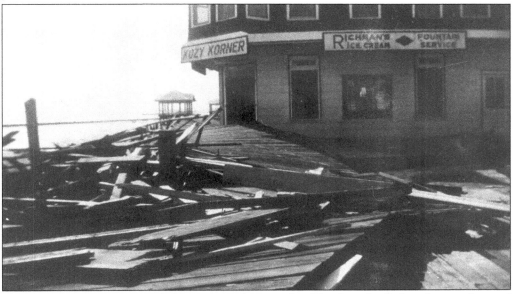

This scene is reminiscent of the game pick-up-sticks. The boardwalk has been splintered into a million pieces. Kozy Korner was located in the Windsor Hotel at 42nd Street and the boardwalk. This shows more evidence of the 1944 hurricane and the devastation that came with it.

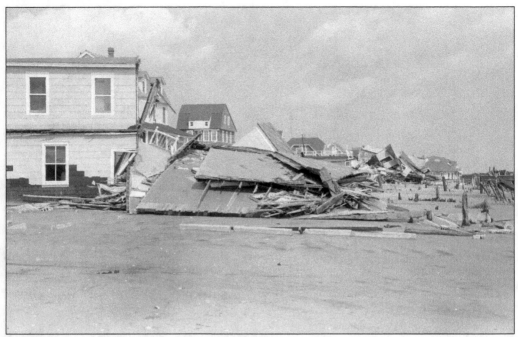

This view shows the caprices of the coastal storms. Some homes are completely destroyed. Others nearby are hardly touched. Massive cleanups are always required after such storms.

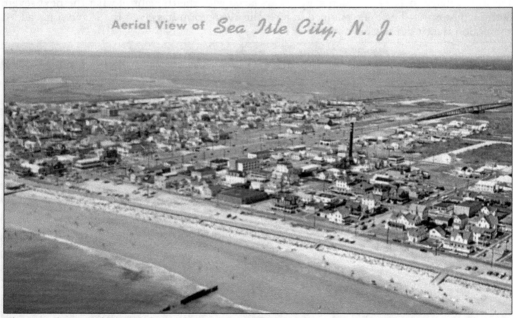

This aerial view of Sea Isle was taken in the mid-1960s, sometime after the storm of 1962. The new bridge is visible in the background. Note the absence of buildings along the coastline. As a result of the 1962 storm, a "dune line" was established. This demarcation moved the building line back an average of one block along much of the island. It was this "storm of the century" that brought out the true strength of the community, as the people worked together to rebuild.

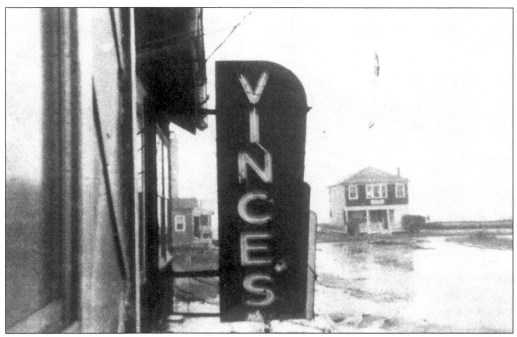

These photographs, taken by a member of the Vince Mollo family from their home above Vince's Hoagie Shop, illustrate a chilling tale. The first photograph was taken at 5:00 P.M. on March 6, 1962, at low tide after a massive high tide had struck the island earlier that day. It shows the Women's Civic Club in apparently good condition. The second photograph was taken about 14 hours later on January 7, 1962. The Women's Civic Club is gone.

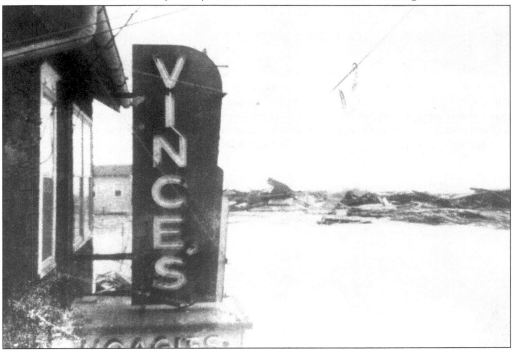

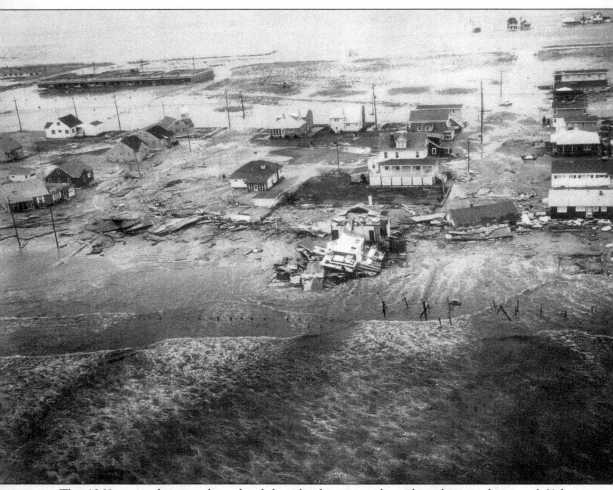

The 1962 storm devastated much of the island, as is evidenced in this aerial view of 60th through 63rd Street. Although the ocean had receded between tides, water and mass wreckage was everywhere, as can be seen in this photograph. The Acme Super Market and Sands Department Store are in the upper left corner. The vast parking lot in front of the stores served as a heliport for evacuation of residents during the storm.

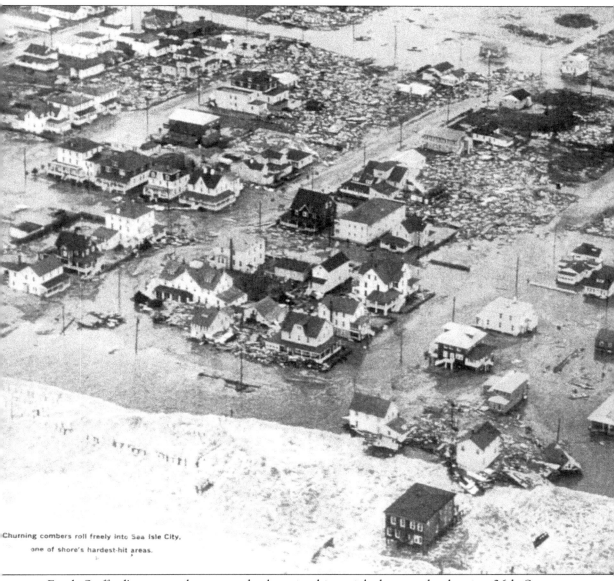

Churning combers roll freely into Sea Isle City, one of shore's hardest-hit areas.

Frank Stafford's summer home stands alone in this aerial photograph, showing 36th Street through 40th Street. His home, the dark house with a flat roof at the lower right, previously had a huge concrete seawall protecting it. Mother Nature had other ideas during the 1962 storm. Note the massive destruction and debris throughout this area of town.

91

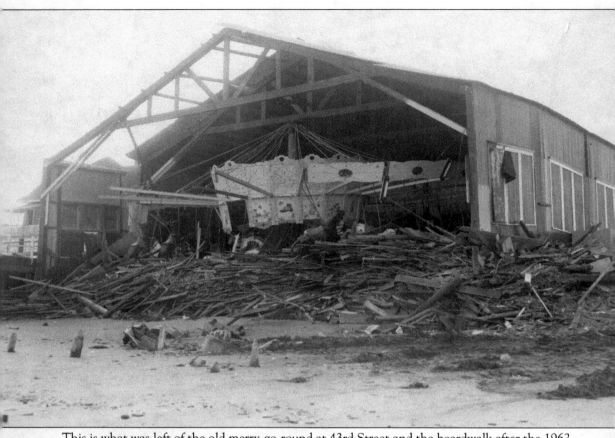

This is what was left of the old merry-go-round at 43rd Street and the boardwalk after the 1962 storm. The merry-go-round evokes fond memories of days when riders would snatch for the brass ring and the free ride that went with it. Some tried to ride for free if lacking the 5¢ price of a ticket back in the 1940s.

Eight

CHURCHES
AND RELIGION

Sea Isle City has been a resort community for the past 120 years. Throughout that period of time, tourists and newly arriving residents have been welcomed wholeheartedly. The church community has been most active in that effort.

By 1900, established religious groups had already set up services on the island for Catholics and Methodists. Because of the relatively large number of residents of German descent, a Lutheran church was built in 1915.

The trolley line that ran to Townsend's Inlet from Sea Isle City was discontinued in 1916. As a result, Lutherans at Townsend's Inlet needed a church at that end of the resort. Trinity Lutheran Church was constructed, beginning in the early 1920s.

Camp Cardinal Dougherty, located along the north end of the resort, was a summer facility for children in need from Philadelphia. A baseball diamond was located on the premises, and many of the resort's young summer and winter residents joined in baseball games in the 1930s. The camp closed in 1940.

St. Rita's Cottage, located at 26th Street and the beach, was used by Augustinian priests. It had a chapel where Mass was said. Throughout the resort there was an abundance of convents, which served various orders of sisters coming from Pittsburgh, Philadelphia, Washington, D.C., New York, and Baltimore. Several of these convents are still here today; others have been lost in storms.

Religious groups have, throughout the years, remained a strong force in providing charitable support to the resort's needs as well as simply offering a warm welcome to all who come to the city.

This welcome sign, although relatively new, represents the true spirit of the community. This spirit of hospitality was evident with the original developers and continues to the present day.

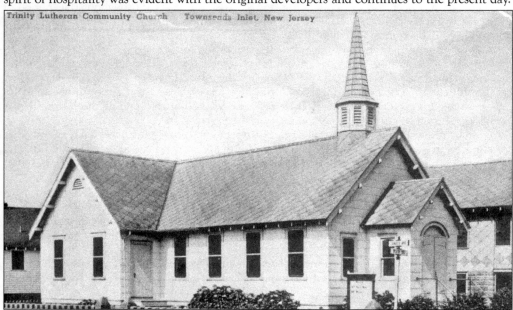

In the early 1900s, the Lutherans at Townsend's Inlet decided to build a place of worship that was more convenient for them, since the trolley line from the center of town had been discontinued in 1916. A groundbreaking ceremony was held in the early 1920s, with Rev. B.S. Dese, pastor of Messiah Lutheran Church in Sea Isle, turning the first spade.

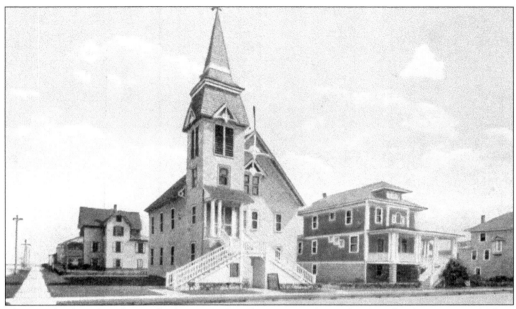

The Methodist church was built in 1883 and was moved to 4500 Landis Avenue in 1905 to get away from the noise of the nearby trains. The parsonage is to the right of the church. The new Methodist church, shown below, was erected in 1985 at Central Avenue and Kennedy Boulevard. Wherever its location, the church has always been a participant and often a leader in community affairs. Pastors such as Rev. Walter Sawn and Rev. George Bailey exemplify the qualities that have made the church so active in the community.

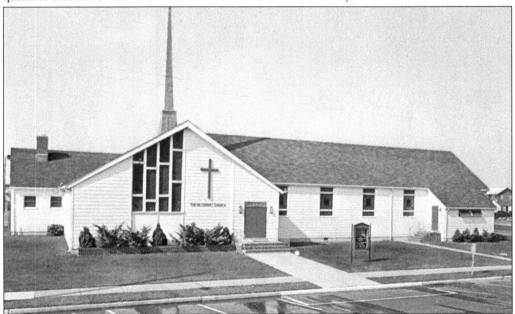

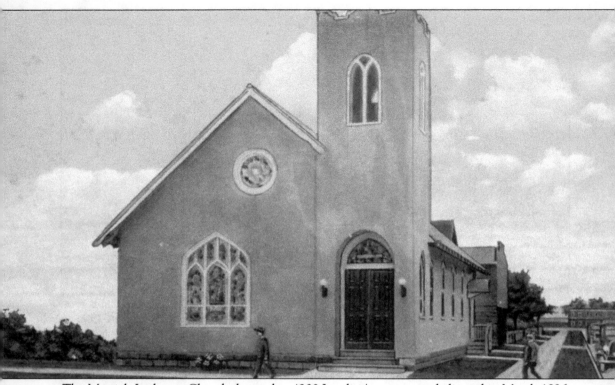

The Messiah Lutheran Church, located at 4200 Landis Avenue, was dedicated in March 1926. Reverend Bair was the pastor of both this church and the one in Stone Harbor. A parsonage was built next to the church at a later date. Reverend Ireland currently leads the congregation and has continued the tradition of outstanding community service.

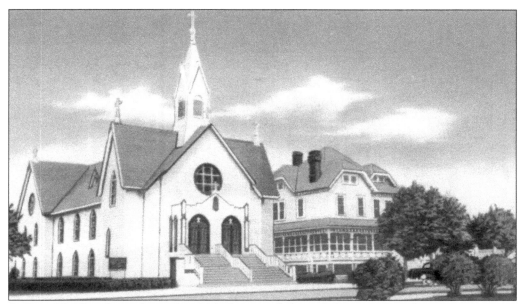

St. Joseph's Church was located at 44th Street and Central Avenue when the cornerstone was laid in 1884. The church was later moved to its present location at 44th Street and Landis Avenue. It seems to have been an easy task to move a building in those days. St. Joseph's has always been a participant and leader in community affairs. Rev. Cletus Moran (earlier) and Rev. Francis Carey (current) exemplify the high-quality leadership of the church.

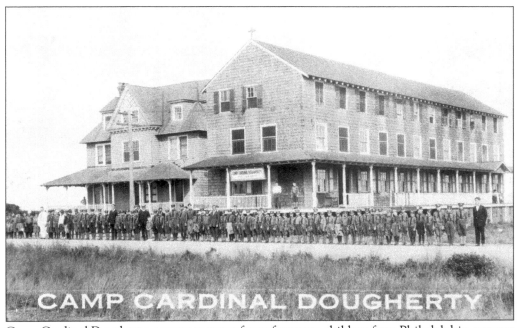

Camp Cardinal Dougherty, a summer resort for unfortunate children from Philadelphia, was run by the archdiocese. The camp had a baseball diamond, and kids from town always went down and played ball with those staying at the camp.

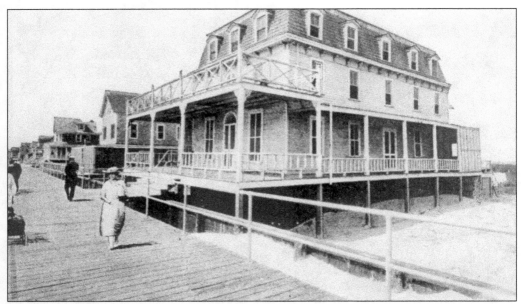

Shown *c.* the 1920s, this building near 50th Street on the boardwalk was owned by the Oblate Fathers and served as a vacation retreat home. Note the mansard-type third-floor level, common in earlier days.

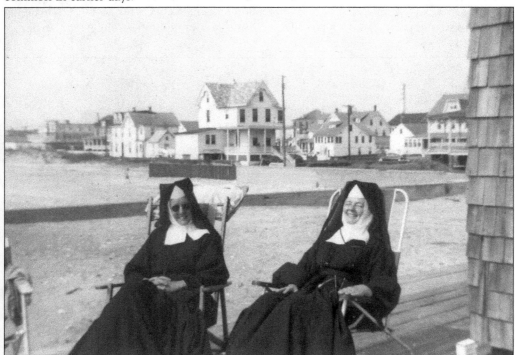

Two Sisters of St. Joseph's order enjoy the summer sun in the 1950s. Today, nuns are rarely seen wearing habits such as these. Although some people may miss seeing the old-fashioned habits, it is unlikely that the Sisters do. The backdrop for this scene provides a good view of homes from 37th Street through 40th Street.

Nine

PEOPLE

Charles K. Landis led the way in putting Sea Isle City on the map. He did this through his clear vision, his ingenuity, and his fortitude. For all of this he is to be commended.

Sea Isle City is made up of a diverse group of individuals, each of whom, in their own way, has contributed much toward the growth of the resort. It is this very diversity that has proven to be the prime ingredient essential to the town's growth. When one considers that little more than a century ago Ludlam's Island was practically barren, it is amazing to see how the resort has evolved so rapidly.

It took people from all walks of life and all ages working together to bring about this transition from cattle-grazing land into the fine resort that tourists flock to today.

Who were the individuals who worked together in developing the resort? Some were businesspeople who recognized an opportunity and put much on the line financially. They invested in land purchase and development, providing some of the finest homes, hotels, restaurants, and other attractions along the New Jersey coast. Then there were others who developed the commercial fishing industry and still others moving forward in the publishing business. Add to them those leaders who surfaced early and often to provide direction for the resort as it faced new and varying challenges through the years. An additional ingredient that has led to the town's success is the work force that forms the backbone of the city.

As important as all of the above have been in Sea Isle City's development, one final factor must be considered: the chemistry that unifies the diverse groups and individuals who have always blended together to shape the community.

The athletic field from 59th Street to 63rd Street and Central Avenue is named in honor of Dr. Frank Dealy, who served the community for many years. He was also the founder of the Surf Hospital (later Mercy Hospital), located between 58th and 59th Street on Landis Avenue. This photograph dates from *c.* the 1950s.

Aurora Fehrle was the driving force behind the movement that provided young people with a wonderful playground. Following the acceptance of her idea and a successful fund-raising effort, the whole community banded together to construct this spot for children to play. Called Play by the Bay, it was opened in 1992 on one section of Dealy Field.

Tennis courts on Kennedy Boulevard? Yes, but long before 41st Street was renamed. This c. 1900 view shows 41st Street from Pleasure Avenue, looking west. Beyond the tennis courts, the old train station is in view. Notice the train tracks on Pleasure Avenue.

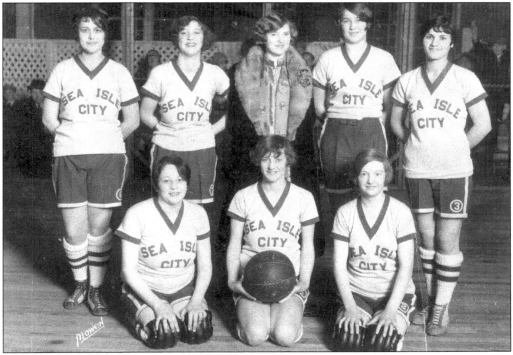

This c. 1920 photograph, undoubtedly taken in the old Excursion House, captures the Sea Isle City girls' basketball team. These young women look ready for action.

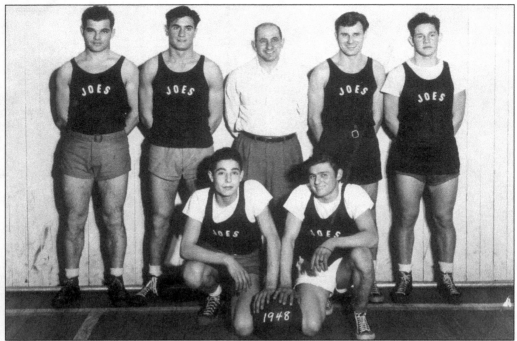

In this 1948 photograph, Joe Pessalano, center, poses with his team. In addition to winter basketball, residents also went offshore to Magnolia Lake, where ice-skating was popular. Back then, the young people had to use their imagination to find interesting activities to pursue.

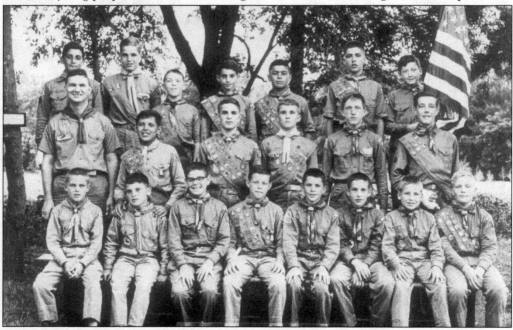

Al Wagner, on the left in the second row, stands proudly with his Boy Scout troop in this early-1960s photograph. A World War II veteran, Wagner has always been active in the community, making life better for the young people.

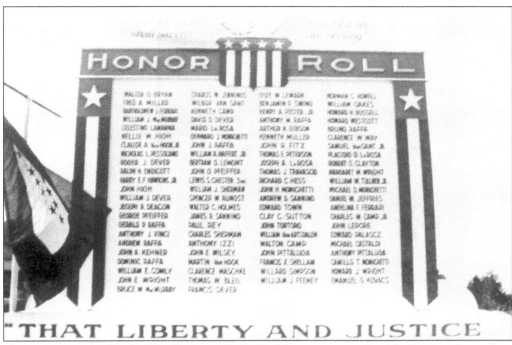

HONOR ROLL

WALTER O BRYAN	CHARLES W JENNINGS	GUY W LEMARK	NORMAN C HOWELL
FRED A MILLER	WILBUR VAN SANT	BENJAMIN F SWING	WILLIAM OAKES
BARTHOLMEW J FERRARI	KENNETH CAMP	HENRY A POSTER JR	HOWARD H RUSSELL
WILLIAM J MacMURRAY	DAVID O DEVER	ANTHONY M RAFFA	HOWARD WESTCOTT
CELESTINO LAMANNA	MARIO LA ROSA	ARTHUR K GIBSON	BRUNO RAFFA
NELLIE M HIGH	GERRARDO J MONCHETTI	KENNETH MULLED	CLARENCE W WAY
CLAUDE A VanHOOK JR	JOHN J RAFFA	JOHN R FITZ	SAMUEL VanSANT JR
NICHOLAS L PESSOLANO	WILLIAM A MARROT JR	THOMAS E PETERSON	PLACIDO G LaROSA
ROGER J DEVER	BERTRAM S LEMONT	JOSEPH A LaROSA	ROBERT O CLAYTON
RALPH H ENDICOTT	JOHN O PFEIFFER	THOMAS J TRAVASCIO	MARGARET M WRIGHT
HARRY E F HAWKINS JR	LEWIS S CHESTER 3rd	RICHARD C HESS	WILLIAM W TUDLIER JR
JOHN HIGH	WILLIAM J SHERMAN	JOHN H MONCHETTI	MICHAEL D MONCHETTI
WILLIAM J DEVER	SPENCER W ALMOST	ANDREW S SANNINO	DANIEL M JEFFRIES
JOSEPH D DEACON	WALTER C HOLMES	EDWARD TOWN	ANGELINA F FERRARI
GEORGE PFEIFFER	JAMES R SANNINO	CLAY C SUTTON	CHARLES W CAMO JR
GERALD P RAFFA	PAUL REY	JOHN TORTORO	JOHN LESORE
ANTHONY J VINCI	CHARLES SHERMAN	WILLIAM VanARTSDALEN	EDWARD PALASCZ
ANDREW RAFFA	ANTHONY IZZI	WALTON CAMP	MICHAEL CASTALDI
JOHN A KEHNER	JOHN E WILSEY	JOHN PITTALUGA	ANTHONY PITTALUGA
DOMINIC RAFFA	MARTIN VanHOOK	FRANCIS X SHELLAM	CAMILLO T MONCHETTI
WILLIAM E COMLY	CLARENCE MASCHKE	WILLARD SIMPSON	HOWARD J WRIGHT
JOHN E WRIGHT	THOMAS M BLEIL	WILLIAM J FEEMEY	EMANUEL O KOVACS
BRUCE W MacMURRAY	FRANCIS DEVER		

"THAT LIBERTY AND JUSTICE

Shown here is the World War II Honor Roll. Chel Lamanna was Sea Isle City's only resident killed during that war. This Honor Roll has since been replaced with a memorial recognizing veterans of all wars. Its location is Kennedy Boulevard and Landis Avenue.

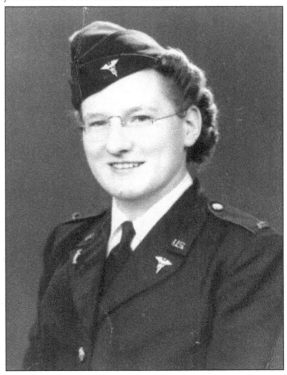

Lt. Margaret M. Wright served as a nurse during World War II. Known locally as "Mickey," she retired as a captain. Nellie High and Angelina Ferrari of Sea Isle also served in the war.

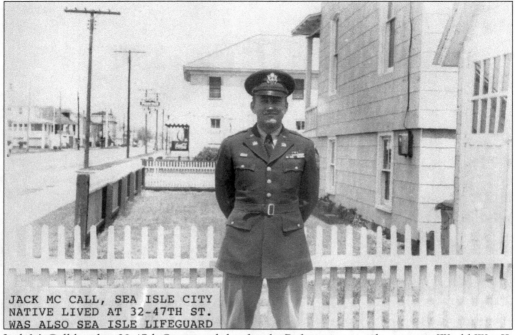

JACK MC CALL, SEA ISLE CITY
NATIVE LIVED AT 32-47TH ST.
WAS ALSO SEA ISLE LIFEGUARD

Jack McCall lived at 32 47th Street with his family. Before entering the army in World War II, he served on the Sea Isle City Beach Patrol. His nephew Joe O'Conner, with his wife, Louise Clare, live at the same location in a new home they built.

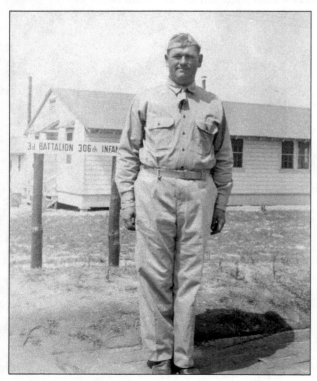

Shown c. 1942 is Ralph Henry Endicott in uniform at Fort Jackson, South Carolina. His family came to Sea Isle City in 1914, when his father was made track foreman for the railroad. Ralph was wounded during the war but arrived home safely. His niece is Harriett A. Reardon Bailey, curator of the Sea Isle City Historical Museum.

During World War II, some hotels in town were requisitioned by the army air force to house recruits during basic training, classification, and assignment. Draftees wore the shoulder patch with pride, and those in training wore the badge for admission to Convention Hall headquarters.

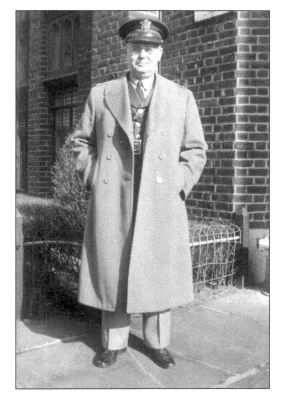

This is a 1942 photograph of Maj. Clarence W. Way, M.D. Way first served in the reserves in 1917 and had been called back to duty at the time of this photograph. His home and office was located at 46th Street and Landis Avenue. The office was closed for the duration of the war.

ARMY SERVICE FORCES
TRANSPORTATION CORPS
ARMY OF THE UNITED STATES

NEW YORK PORT OF EMBARKATION

LA. ROSA. JosepH. A.

returned to the UNITED STATES on the ship M.S. JohN ERicssoN which sailed from LE HAVRE on 30- September 1945

Sig. _____
Title _____

This certificate was issued to Joseph A. La Rosa Sr. on September 30, 1945, shortly after the Japanese surrender. La Rosa returned home to his wife, Alice, who was always active in the community, particularly with the Sea Isle City Historical Society and Museum. He later became superintendent of the Sea Isle City Public Works Department. Son Pat La Rosa holds this position today, and son Joseph A. La Rosa Jr. is a school administrator.

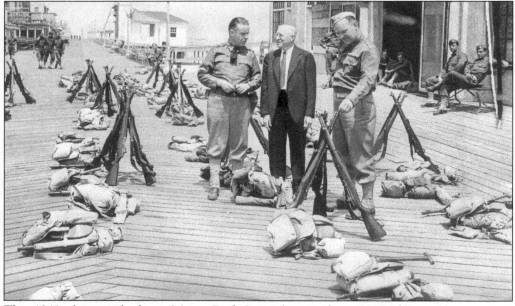

This 1942 photograph shows Mayor Fred Cronecker, in the suit, speaking with two troop members on bivouac maneuvers. The Pier Movie, later renamed the Madeline, is on the right. On the left are the Braca Bowling Alley and the Sea Spray.

Irving Fitch was obviously a conscientious guard when he stood watch during World War II. Earlier, he had served as Sea Isle's mayor. Coast Guardsmen on horseback regularly patrolled the beaches at this time. Dark shades were drawn on homes to minimize a clear view from potential preying German submarines offshore.

Punch That Clock

You watch by day and you watch by night,
You Mr. Aux do it with all your might.
Some days are cheery, and some days are dreary,
You Mr. Aux keep on watching and don't get weary.
Some of us are old, some of us are bald
You Mr. Aux by your country were called.
Keep your eyes wide open, your mouth shut tight
You Mr. Aux can't take your job light.
Your stretch of six may seem like ten,
But something might happen, you know not when,
So scan the Ocean and scan the sky,
Yes, scan the beach too, there could be a spy.
You know what to do and can do it well
But punch that clock, and let all else go to hell.

Poem written by Irving Fitch while on watch in the Coast Guard Tower at 32nd and the Beach in 1944.

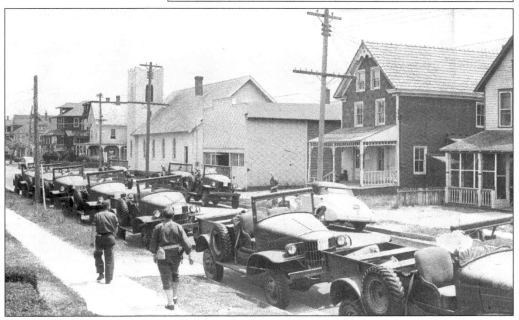

Army jeeps are lined up on 42nd Street, just west of Landis Avenue *c.* 1942, ready to speed the 114th Infantry (North Jersey) out of Sea Isle City should the enemy try a beach landing. Gas rationing was in effect for civilians. Any automobile whose owner used the most common mixture of gasoline and kerosene could be spotted a mile away by the long trail of smoke that it left in its wake.

Joan Crawford poses for a photograph for distribution to the servicemen of World War II. Lana Turner and Betty Grable were also common pinup subjects of the day. USO tours were conducted during the war. Bob Hope had a traveling troop of movie stars and entertainers who performed overseas.

In his Coast Guard uniform, William A. Haffert Jr. reports on World War II. He grew up in Sea Isle City, where his family owned and operated the Garden State Publishing Company. After the war ended, he returned home to his bride, Jean.

Sea Isle City Veterans of Foreign Wars Post 1963 is the focal point where veterans meet and socialize with others. For many years it has been an integral part of the town, helping out in every way possible with time and donations to worthy causes. Service veterans are most aware of and appreciative of the respect they receive in return from the community.

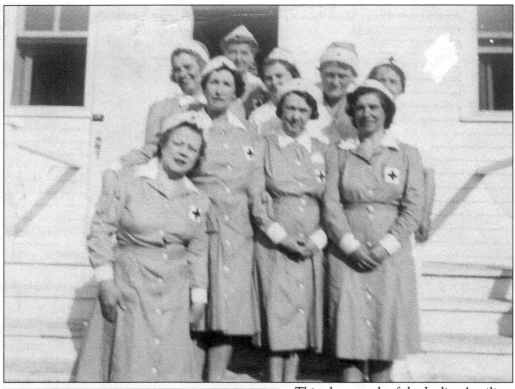

This photograph of the Ladies Auxiliary was taken during World War II. These women volunteered their services to assist in the war effort. Nearly all of them had a husband, a son, a relative, or a friend serving in the war.

Two women pose alongside their new 1931 Chevrolet. Emile Dean, left, and Miriam Barnett are on the way to the beach or are returning, as can be evidenced by the bathing cap and the all-wool bathing suit. Is anyone itchy?

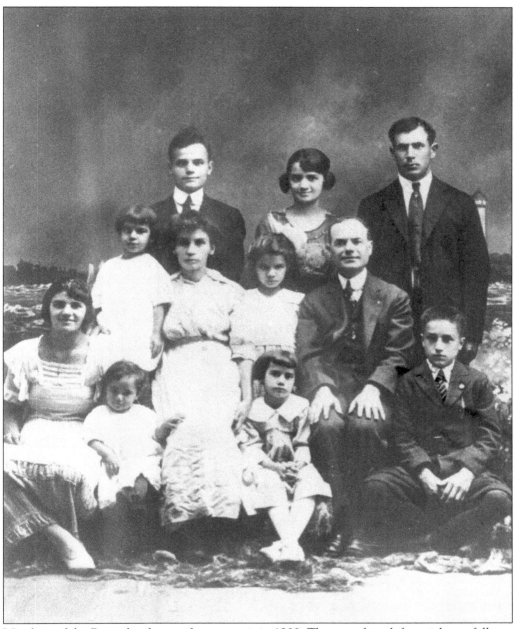

Members of the Braca family pose for a portrait in 1922. They are, from left to right, as follows: (front row) Philomena, Angela, Mary, and Lou Braca Jr.; (middle row) Henrietta, Madeline (mother pregnant with Rita), Jeanette, and Lou Braca Sr. (father); (back row) John Braca and Lena and Luke Costaldi. The Bracas came to Sea Isle City c. 1900 and gradually formed Braca Enterprises, consisting of a café, a movie theater, a news store, and later the Madeline Theater and Pier. Members of the Braca family today continue to be prominent in the community.

Pictured is Peter Bossow Jr., a Sea Isle City lifeguard from 1984 to 1990. "He was a dedicated, fun guy to serve with," is heard frequently when his name comes up. A graduate of La Salle University, he married Marci Kuttler. Bossow was stricken with cancer and died in 1999. Evidence of strong community spirit is the Crossing the Finish Line program, which Peter and Marci Bossow conceived of and their family and friends made a reality. This nonprofit organization provides vacations to assist other families stricken with cancer.

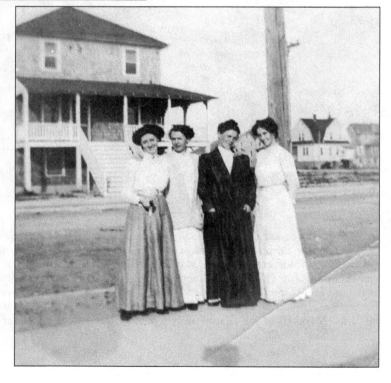

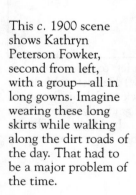

This c. 1900 scene shows Kathryn Peterson Fowker, second from left, with a group—all in long gowns. Imagine wearing these long skirts while walking along the dirt roads of the day. That had to be a major problem of the time.

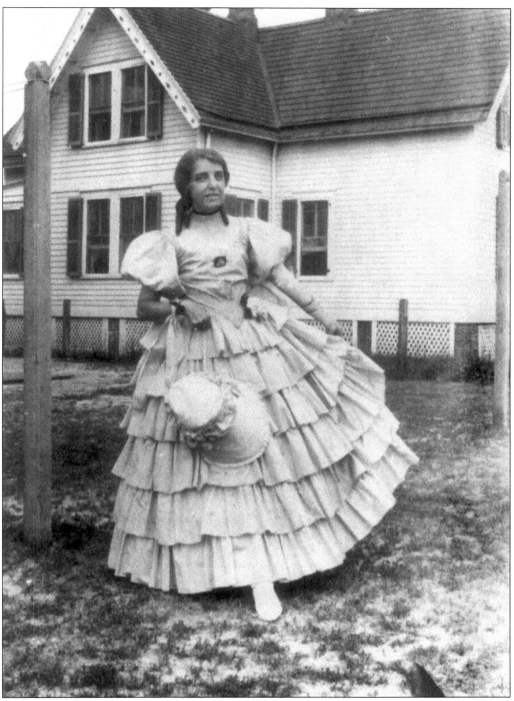

All dressed up in her tiered formal gown, Hattie Powell poses prior to going to the Excursion House Ball in 1918. After 1919, Lifeguard Balls were also held in the Excursion House, which was one of the social centers of the resort, along with places such as Cronecker's Hotel and Restaurant.

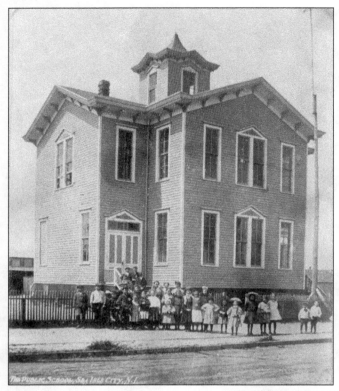

This building still stands, without the cupola, on 44th Street. It is now a convent for the St. Joseph Sisters. Constructed in 1893, it was originally the resort's first public school building. Prior to that, students attended class at various other locations on the island.

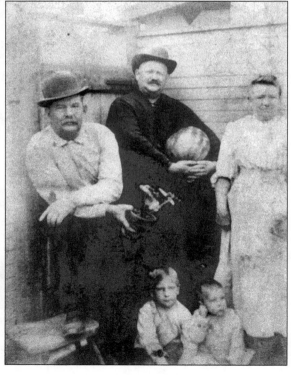

This 1908 scene shows the Fullerton family gathered for an informal portrait. Harry and Howard Barth are seated, and Harry Fullerton, John Fullerton, and Magdalena Fullerton are in the top row. The Fullertons had a restaurant on the bay that was popular for its home-style cooking. There was only one drawback: it was best to go for dinner at low tide to ensure dry feet.

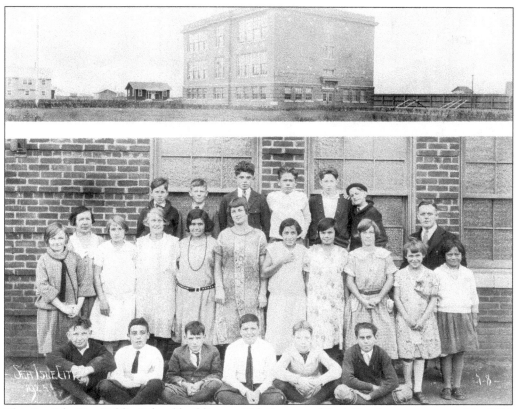

This Sea Isle City Public School building at 45th Street and Park Road was constructed in 1914 and was demolished in 1970, when the present school was built on the same site. In the lower frame of this image is the 1925 graduating class, dressed very smartly.

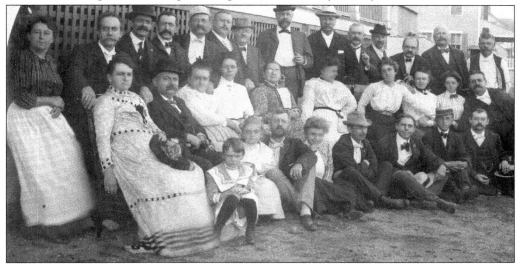

These summer visitors are dressed for some special occasion c. 1900. The men display a variety of hats but appear to be somewhat uniform in having a mustache. Could the grim expression on some have been prompted by a fear of the camera?

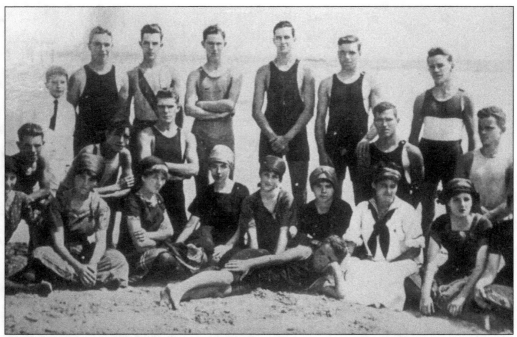

At the beach, bathing hats were considered a must for the women *c.* 1910. The men appear to be comfortable in their wool bathing suits. How can they be?

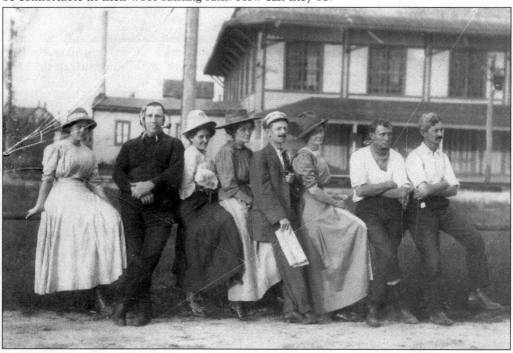

A close inspection of this scene reveals that this group has a sense of humor, with the hat switching. This *c.* 1900 photograph, donated to the Sea Isle City Historical Museum, comes from a collection of glass negatives. Note the crack in the glass on the left side.

116

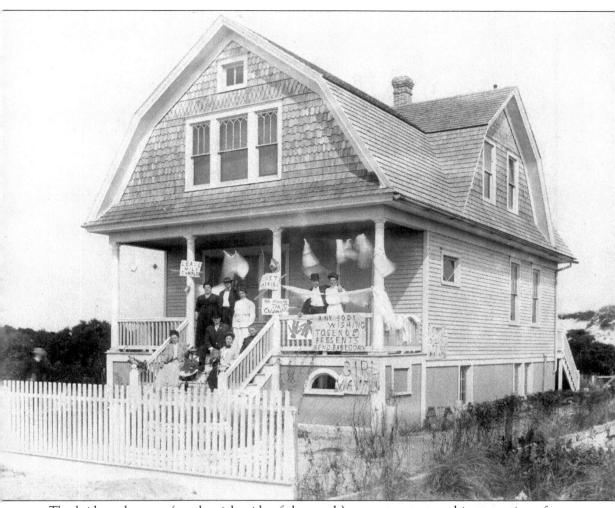

The bride and groom (on the right side of the porch) appear content and in possession of a good sense of humor, as evidenced by the signs posted everywhere. Surely the entire group remembered this *c.* 1900 event for a long time afterward. The cottage appears to be beachfront, judging from the dunes surrounding it.

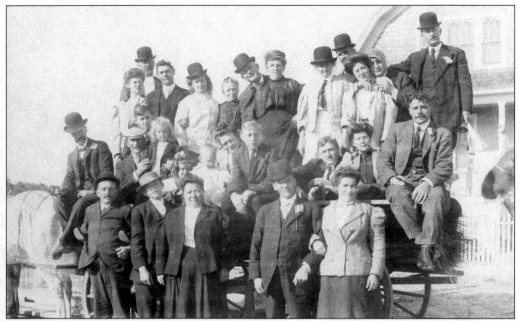

A good old-fashioned hayride is in progress. Note the gentleman with the bell at the far right in the top row. A good bit of hat switching has been going on. The horse is having a rest while the wagon is stopped for this *c*. 1900 photograph.

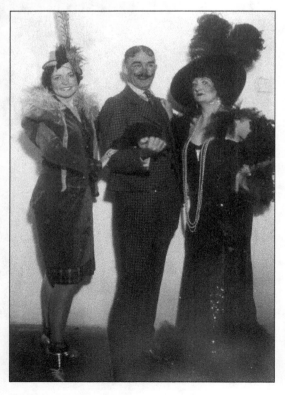

This group is probably dressed for a ball. On the left is Virginia Knauer, a longtime resident of 44th Street who served as consumer advocate during the administration of Pres. Richard Nixon.

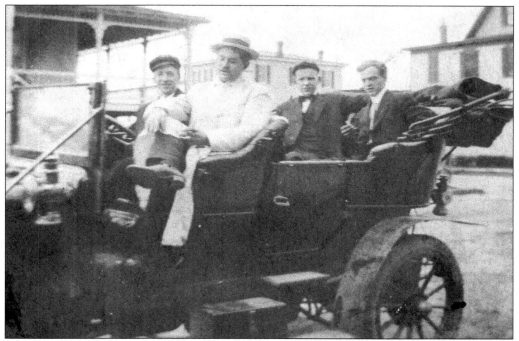

This grand open car must have been a lot of fun to drive around the island *c.* 1900. Notice the lantern hanging from the rear. The automobile was still in competition with the horse and carriage back then.

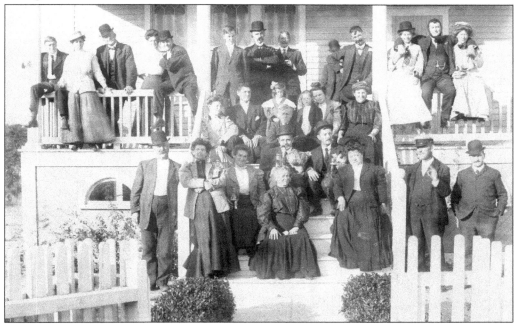

These spirited people may have been in attendance at a wedding. They appear to be happy and not above the old hat-switch trick. They seem to be placing too much trust on the porch rails. Maybe they were built stronger at the turn of the century.

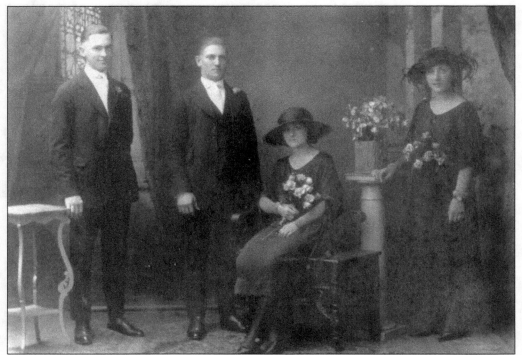

Harry Barth's family ran the Fullerton Restaurant in Townsend's Inlet for many years. This photograph shows Harry and Margaret Barth posing with their wedding party. They lived on Venician Road. Barth later served as commissioner of Sea Isle City.

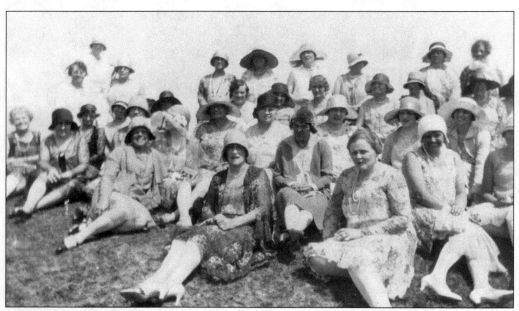

Women attending Bess Souder's birthday party c. 1920 display a splendid array of fancy hats. The women do not seem to mind sitting on the grass as they enjoy the day's outing.

Dressed to go anywhere but the beach, parents John Cassidy Sr. and his wife, Mary Anne, sit in front of the following, from left to right, Charlie Cassidy, Mae Harron, Mary Anne Cassidy, and Frank Stafford.

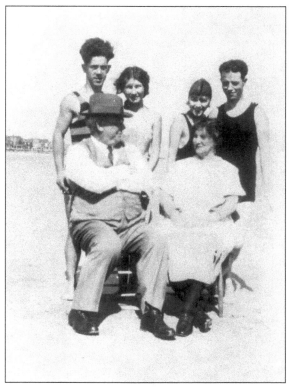

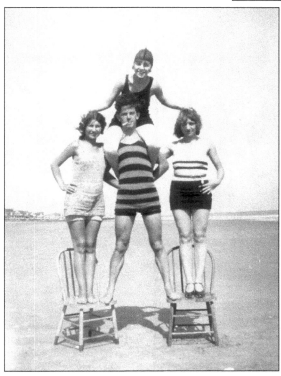

In this *c.* 1920s photograph, Charlie Cassidy is surrounded by a group of lovely ladies who are putting the chair to an unusual use.

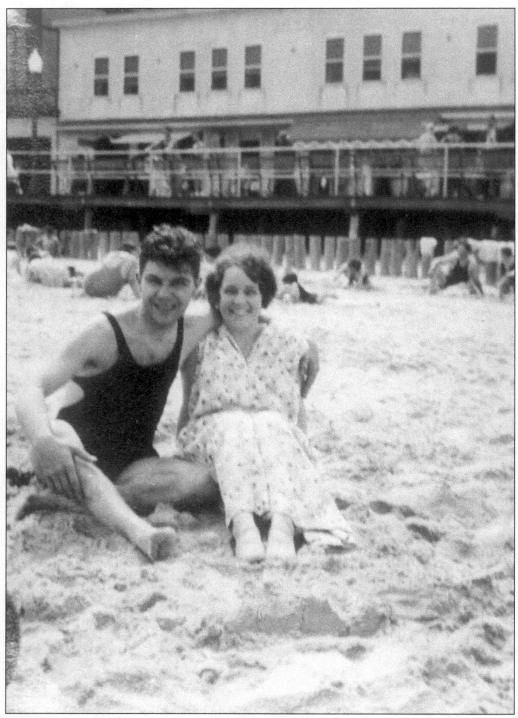

Sam Thompson Jr. and Helen Fitzsimmons are enjoying the beach at 40th Street. Thompson is wearing the typical wool bathing suit of the 1920s, while Helen is covered from feet to chin. Imagine their reaction should a young woman stroll by in a bathing suit of today.

122

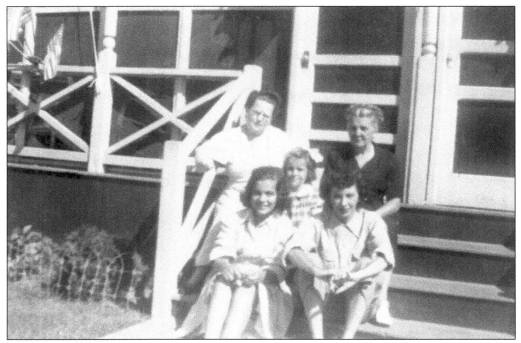

This scene was a common one: a group sitting together on the front steps. The group is enjoying the day at Sam and Martha Thompson's home at 3905 Landis Avenue *c.* the 1950s.

These two young fellows on the boardwalk at 55th Street outside the Strand Apartments seem to be enjoying a Dixie Cup before calling it a day on the beach. They are Charlie Cassidy Jr., left, and his cousin Gene.

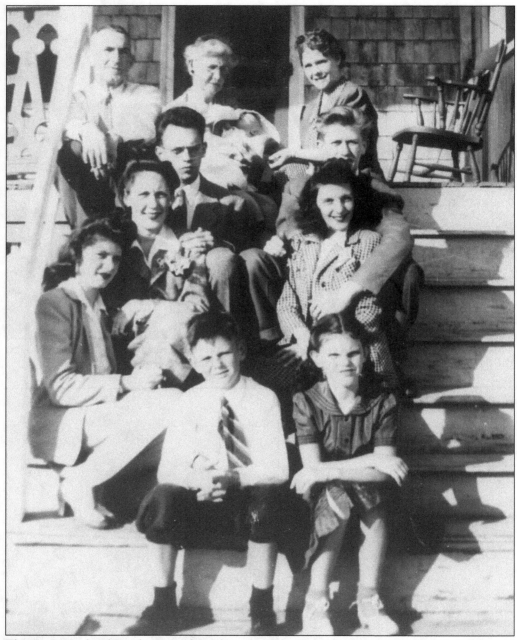

The Finnerty family gathers on the side step of the Strand Apartments at 55th Street and the beach c. the 1940s. The Finnerty children sit on the lower steps. Behind them are, from left to right, their father, Joe Finnerty Sr.; Strand owner Mary Anne Cassidy holding her first great-grandchild, Dennis Dziena; and their mother, Kay Cassidy Finnerty.

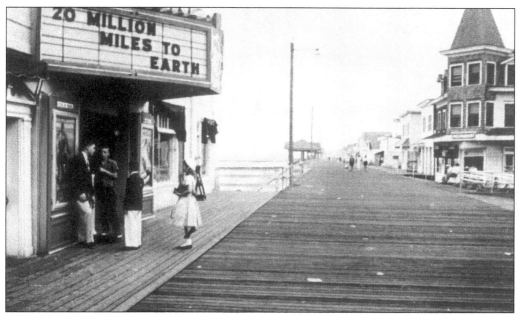

Bill and Etta Creighton, prominent businesspeople in Sea Isle City for years, had on this day in the 1950s sent their three children up to the Madeline Theater to see a movie. The children, from left to right, are Mark Creighton, an unidentified child, and Vance and Betty Jean Creighton. Judging from their dress, this picture must have been taken either after church on Sunday or after another special occasion.

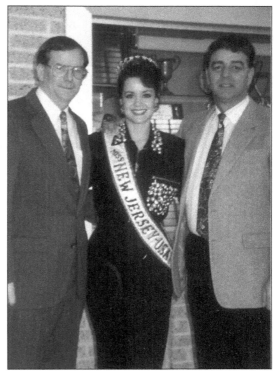

City officials perform a pleasant task c. 1990. They are, from left to right, Mayor Mike McHale, Miss New Jersey, and Commissioner Steve Libro. Commissioner Jim Iannone, not shown, also served the city at this time. McHale was captain of the lifeguards in earlier years.

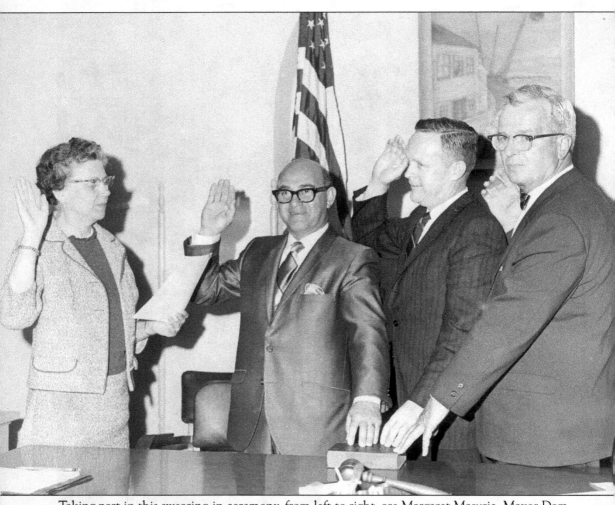

Taking part in this swearing-in ceremony, from left to right, are Margaret Mazurie, Mayor Dom Raffa, Commissioner Bill Wilsey, and Commissioner Claude "Bud" Town. This photograph was taken in 1977 and represents one of the final acts Margaret Mazurie performed as city clerk, having served in this capacity since 1933. Raffa served first as commissioner and later as mayor. Wilsey served first as mayor and later as commissioner. Town resigned after a brief period to spend more time with his family. It is through Raffa's efforts and cooperation that the Sea Isle City Historical Museum was able to get its start as an outgrowth of Sea Isle City's 1982 centennial celebration.

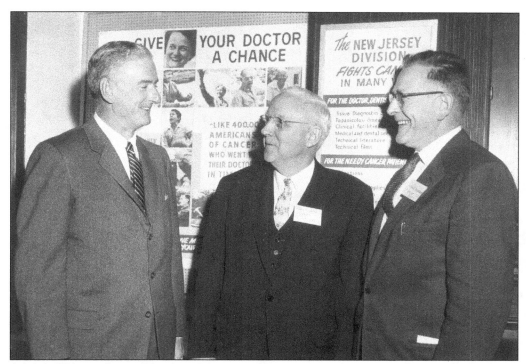

Adolph Wilsey, editor of the *Cape May County Times,* center, is shown at a c. 1960s cancer fund-raising event. Throughout his life, Wilsey was dedicated to Cape May County and particularly to Sea Isle City community projects. As a newspaperman, he excelled. He and his family resided at 38th Street and Pleasure Avenue.

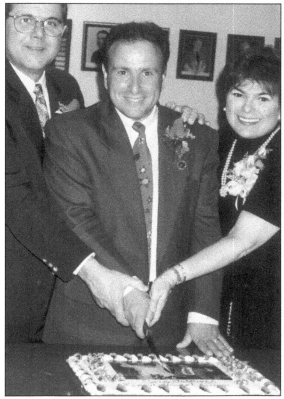

The present Sea Isle City leaders celebrate their successful bid for office in 1997. They are, from left to right, Commissioner Jim Iannone, Mayor Len Desiderio. and Commissioner Angel Dalrymple. Iannone is now serving his 16th year as commissioner, Desiderio his eighth year as mayor, and Dalrymple (Sea Isle's first woman commissioner) her first term as commissioner. They continue to provide the fine leadership that the resort has always had.

Credits:

Photo by Dale Gerhard, courtesy of The Press of Atlantic City

Sea Isle City Historical Society

Sea Isle City Millennium Committee • *Sea Isle City Tourism Commission*

This enthusiastic crowd has gathered at JFK Boulevard and the Promenade to welcome in the new millennium. Commissioner Angel Dalrymple, wanting to provide something special for the youth in the community, featured a Night in Paris celebration as part of the evening's activities. The Sea Isle City Tourism Commission, directed by Dave Farina, and the Millennium Committee, chaired by Mike Stafford, cooperated in planning the celebration which included a Photo Shoot from a fire engine extension ladder suspended 40 feet up, followed by fireworks. All made for a spectacular celebration. Mayor Len Desiderio and Dalrymple are visible in the lower left section of the photograph, near the banner. Commissioner Jim Iannone is also among the crowd, as well as Irene Jameson, publicity director. As the 20th century ended and the 21st century began, Sea Isle City's people looked back with pride in their accomplishments as they looked forward to the challenges of a new age.